BRAD KAHLHAMER ALMOST AMERICAN

Madison Art Center
December 3, 2000–February 11, 2001

Aspen Art Museum
June 1, 2001–July 22, 2001

This volume was co-published by the Aspen Art Museum and the Madison Art Center in conjunction with the exhibition **BRAD KAHLHAMER: ALMOST AMERICAN**. Major funding for the project and its Madison presentation was provided by a grant from the Ameritech Foundation; a grant from the Dane County Cultural Affairs Commission with additional funds from the Madison Community Foundation and the Overture Foundation; The Art League of the Madison Art Center; the Exhibition Initiative Fund; the Madison Art Center's 2000–2001 Sustaining Benefactors; and a grant from the Wisconsin Arts Board with funds from the State of Wisconsin. The Aspen Art Museum presentation is sponsored by the AAM National Council, with additional support provided by Nancy and Robert Magoon.

Library of Congress Cataloging-in-Publication Data

Hoptman, Laura J., 1962–
 Brad Kahlhamer: Almost American/Stephen Fleischman, Dean Sobel, foreword and acknowledgements; [text by] Laura Hoptman, Sara Krajewski.
 p. cm.
 Catalog of an exhibition held at the Madison Art Center, Dec. 3, 2000–Feb. 11, 2001 and the Aspen Art Museum, June 1, 2001–July 22, 2001.
 Includes bibliographical references.
 ISBN 0-913883-29-8
 I. Kahlhamer, Brad, 1956- II. Krajewski, Sara, 1970- III. Madison Art Center. IV. Aspen Art Museum (Aspen, Colo.) V. Title.

N6537.K225 A4 2000
709'.2—dc21

00-051520

LC
709.2
HOP 6·06

Printed and bound in the United States of America
Edition of 1500
All rights reserved

Editor: Mary Maher, Madison, Wisconsin
Design: Deborah Littlejohn and Santiago Piedrafita, Minneapolis, Minnesota
Printer: American Printing Company, Inc., Madison, Wisconsin

Available through
D.A.P./Distributed Art Publishers
155 Sixth Avenue, 2nd Floor, New York, New York 10013
T. 212.627.1999/F. 212.627.9484

Photography of Brad Kahlhamer's art courtesy of Deitch Projects.
All other photography by Brad Kahlhamer.

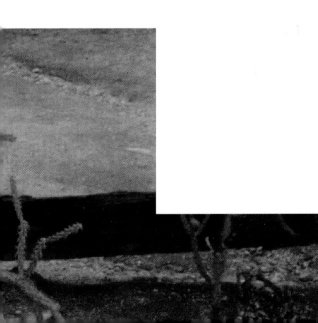

BRAD KAHLHAMER ALMOST AMERICAN

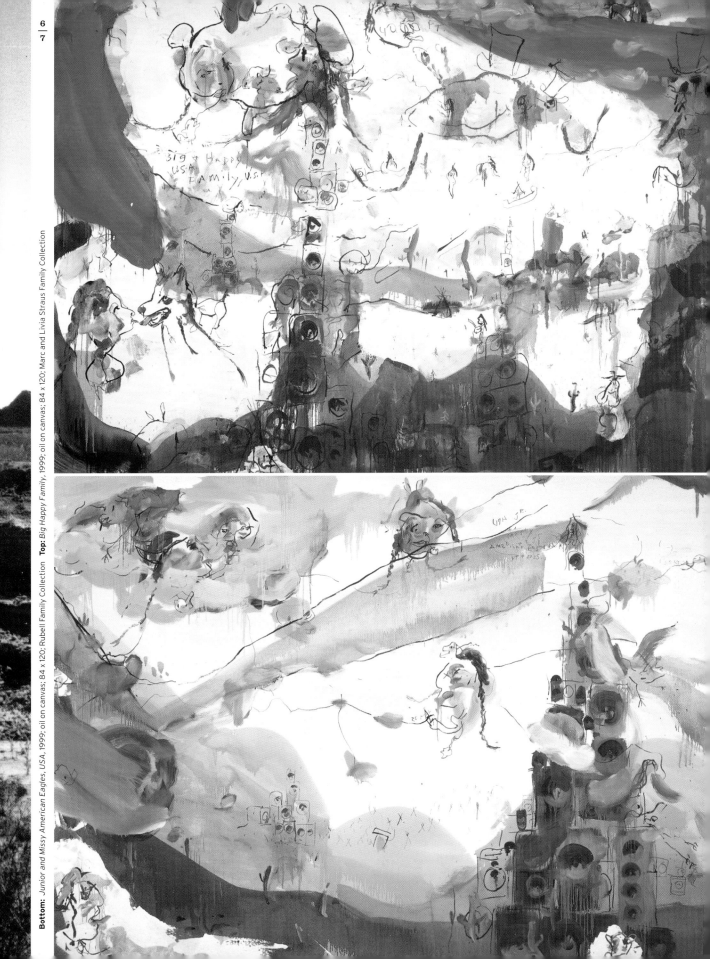

Bottom: *Junior and Missy American Eagles, USA*, 1999; oil on canvas; 84 x 120; Rubell Family Collection **Top:** *Big Happy Family, USA*, 1999; oil on canvas; 84 x 120; Marc and Livia Straus Family Collection

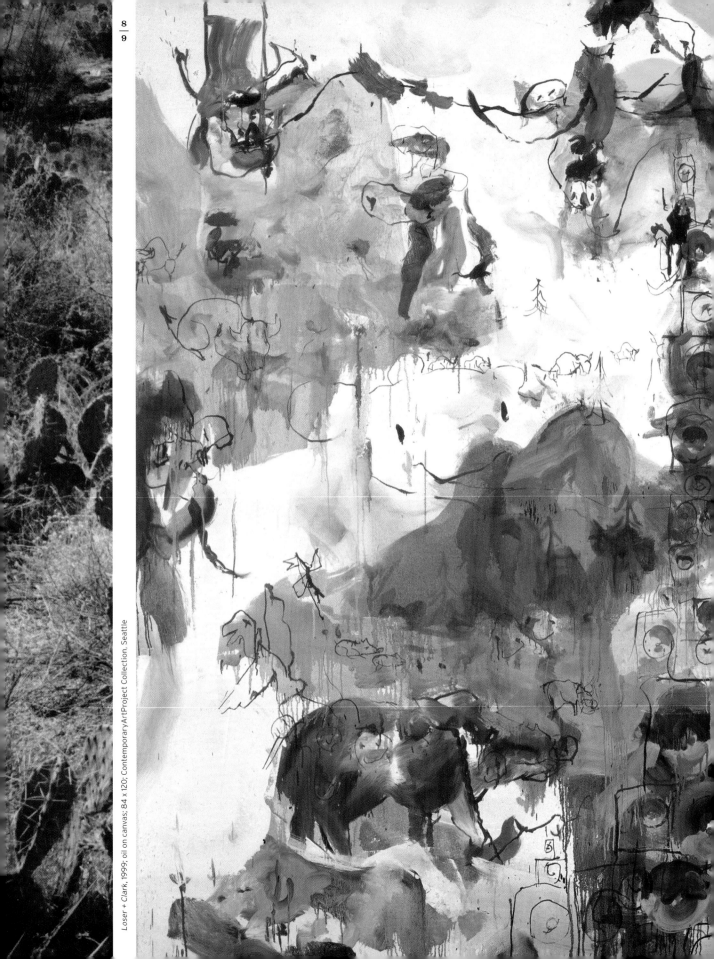

Loser + Clark, 1999; oil on canvas; 84 x 120; ContemporaryArtProject Collection, Seattle

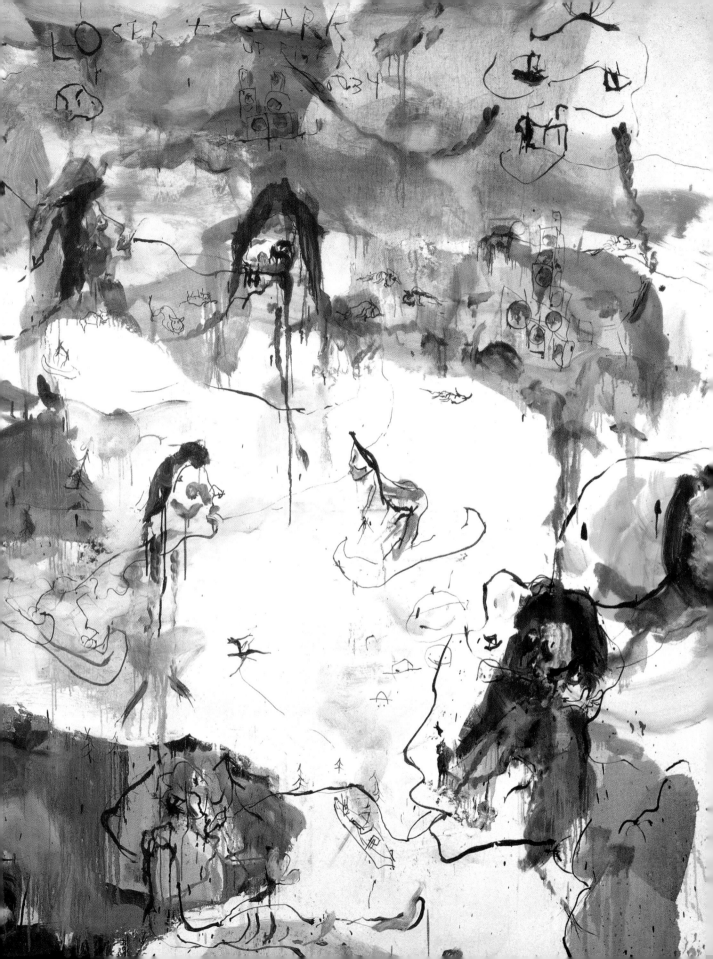

Left: *Corps of Discovery Sacagawea + Kid*, 1999–2000; watercolor and ink on paper; 29 3/4 x 22 1/2; Collection of American Express Financial Advisors Right: *Little War Pony*, 1999; oil on canvas; 84 x 60; Collection of John P. Morrissey

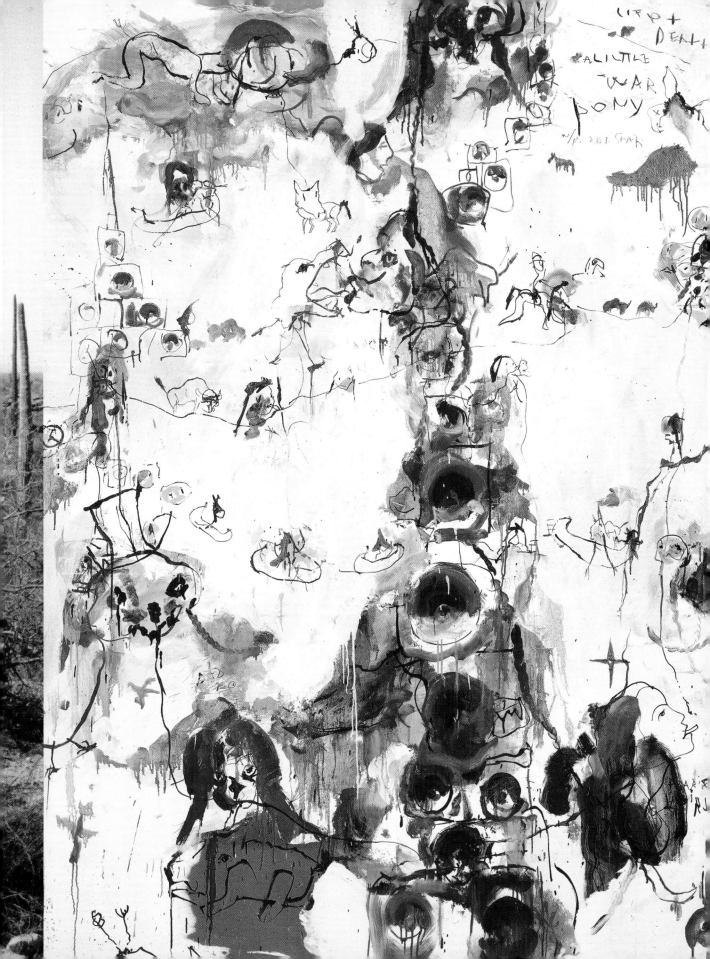

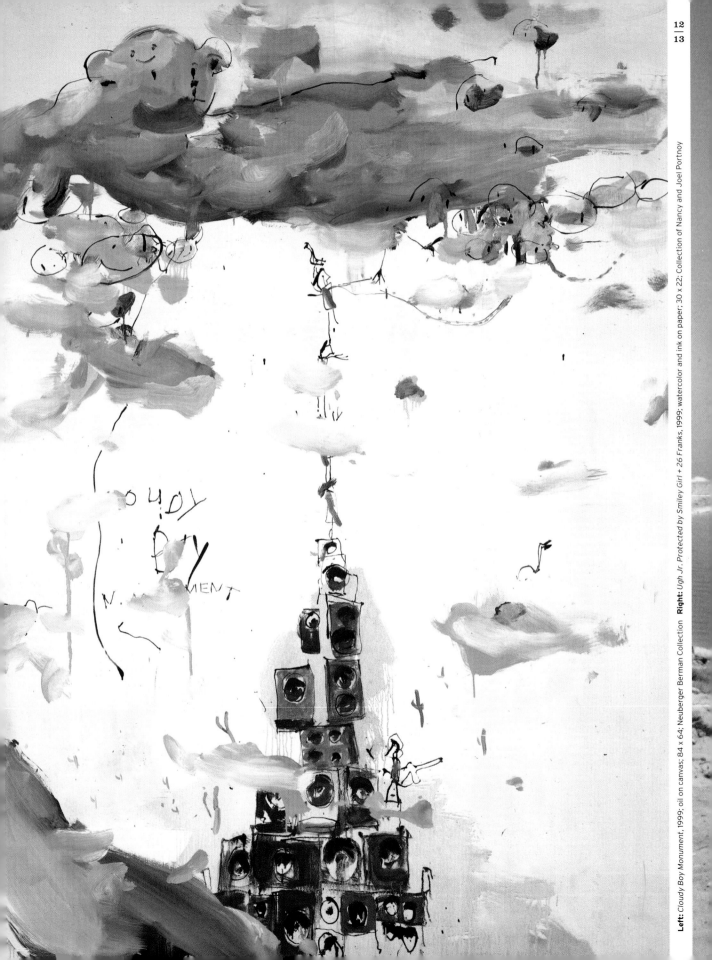

Left: *Cloudy Boy Monument*, 1999; oil on canvas; 84 x 64; Neuberger Berman Collection **Right:** *Ugh Jr. Protected by Smiley Girl + 26 Franks*, 1999; watercolor and ink on paper; 30 x 22; Collection of Nancy and Joel Portnoy

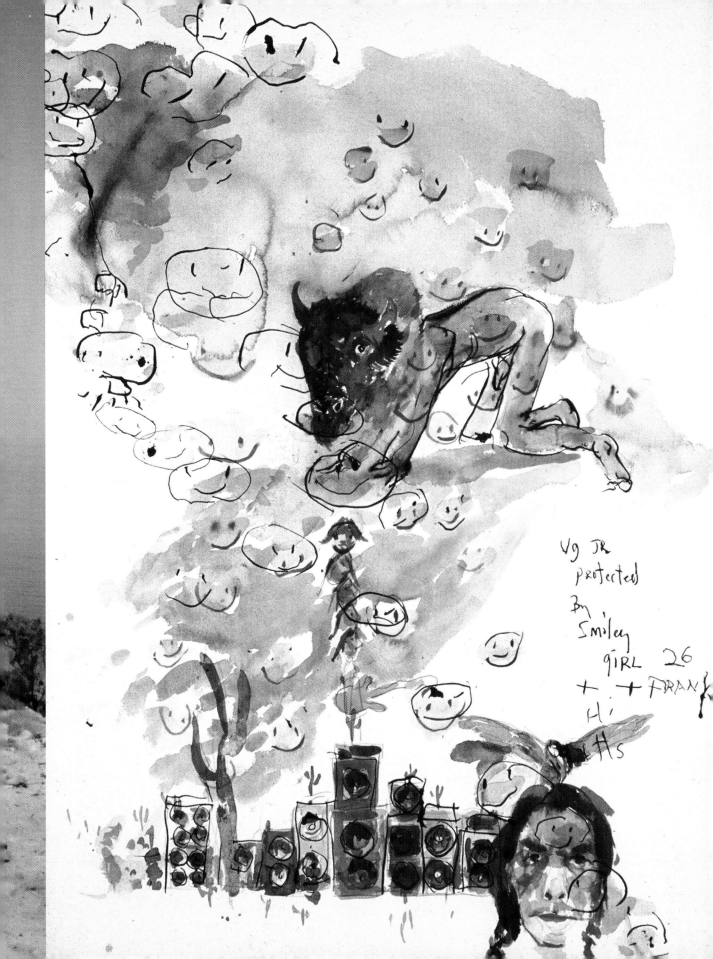

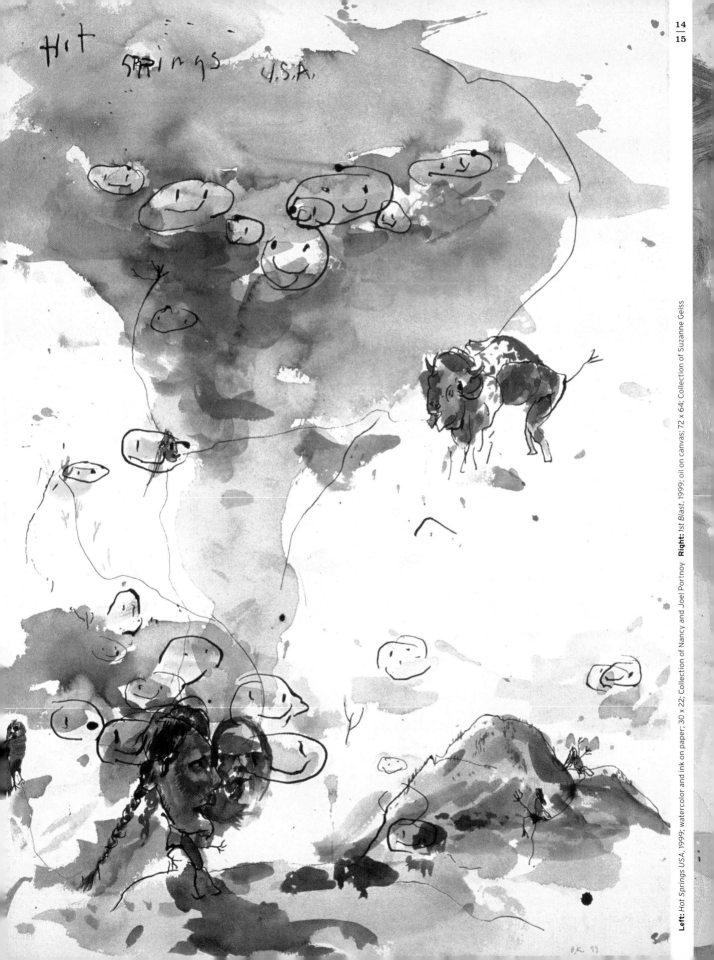

14
15

Left: *Hot Springs USA*, 1999; watercolor and ink on paper; 30 x 22; Collection of Nancy and Joel Portnoy **Right:** *1st Blast*, 1999; oil on canvas; 72 x 64; Collection of Suzanne Geiss

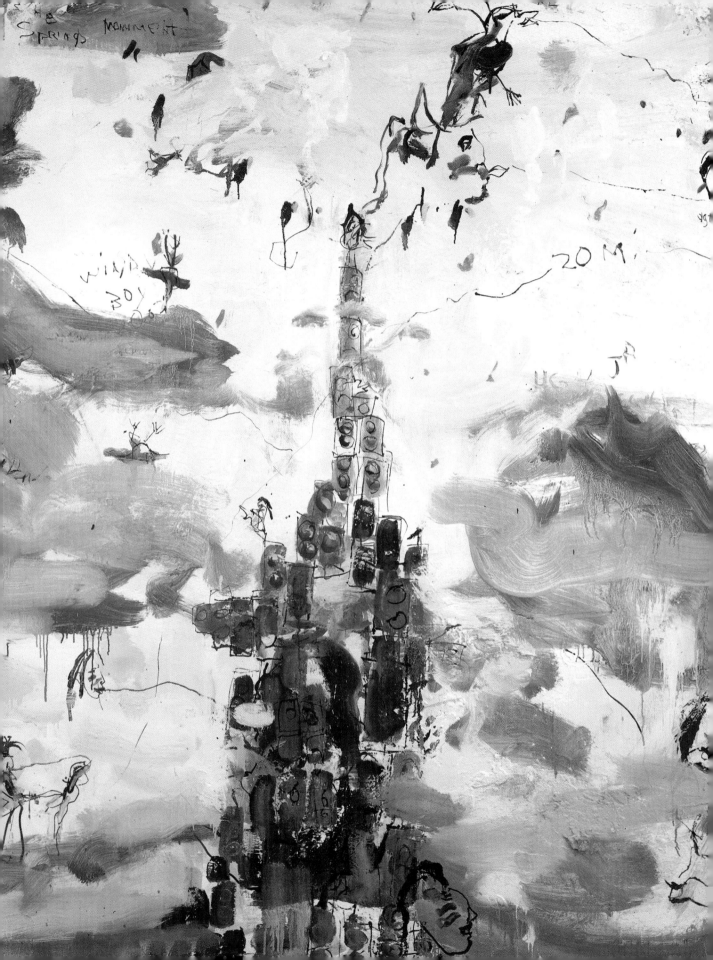

MILLENIAL GROUND SQUIRREL
FLAGSTAFF, U.S.A.

3000 grams
SQUIRRLY

nical
celebrating
people

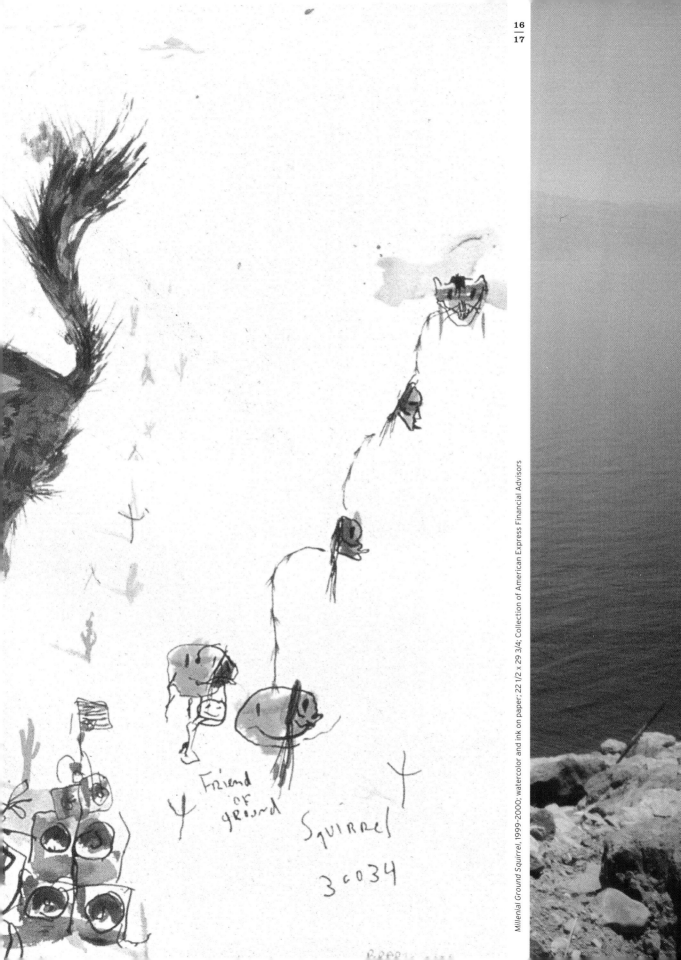

Friend
or
ground

Squirrel

30034

Millenial Ground Squirrel, 1999–2000; watercolor and ink on paper; 22 1/2 x 29 3/4; Collection of American Express Financial Advisors

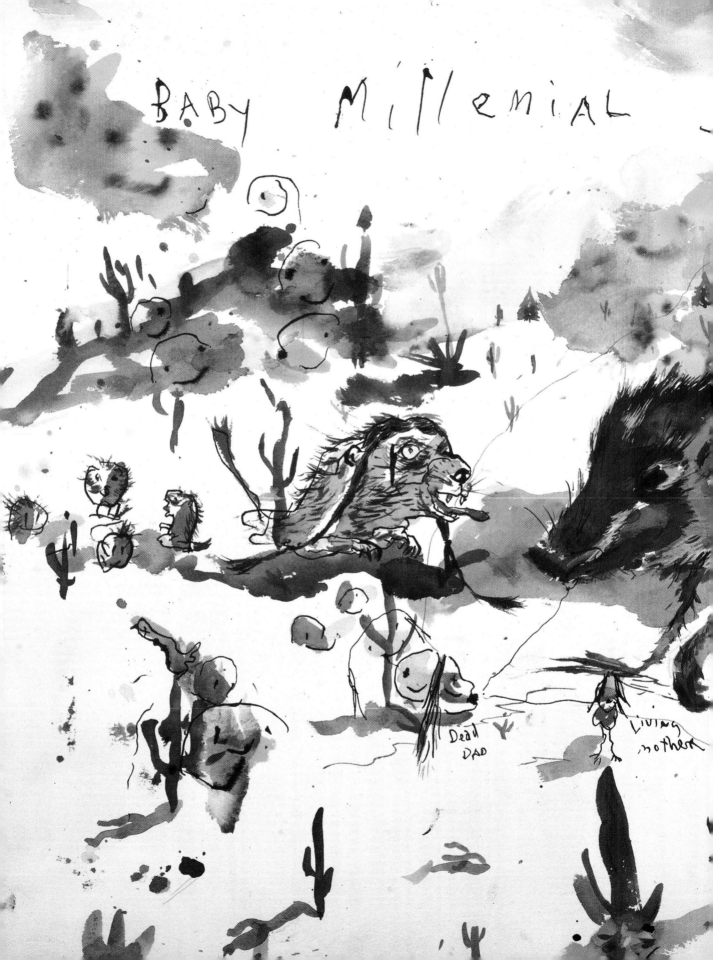

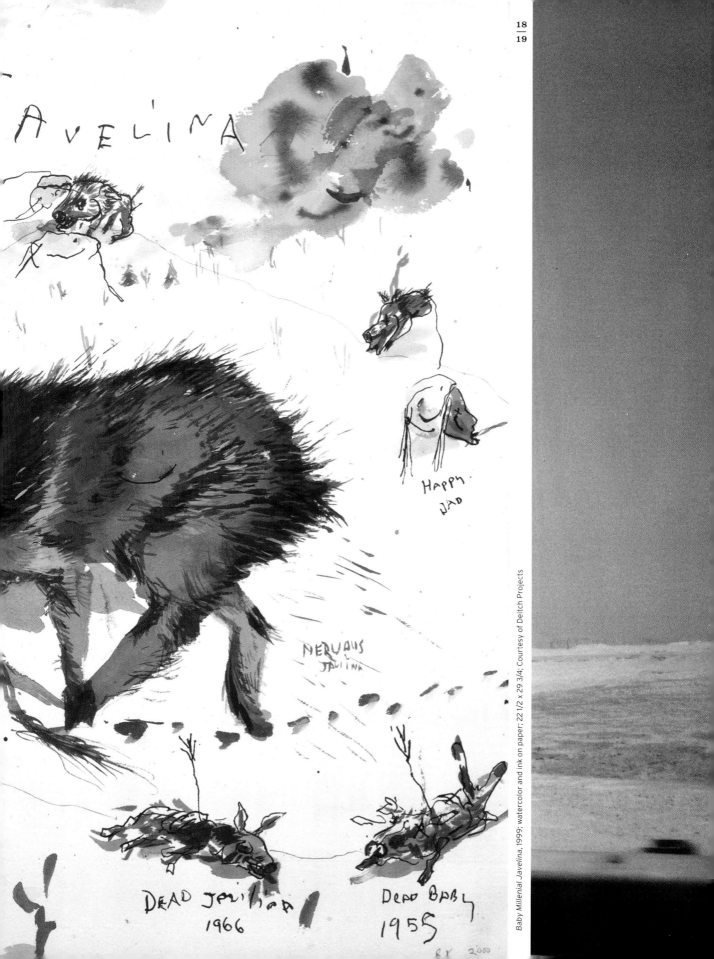

Baby Millenial Javelina, 1999; watercolor and ink on paper; 22 1/2 x 29 3/4; Courtesy of Deitch Projects

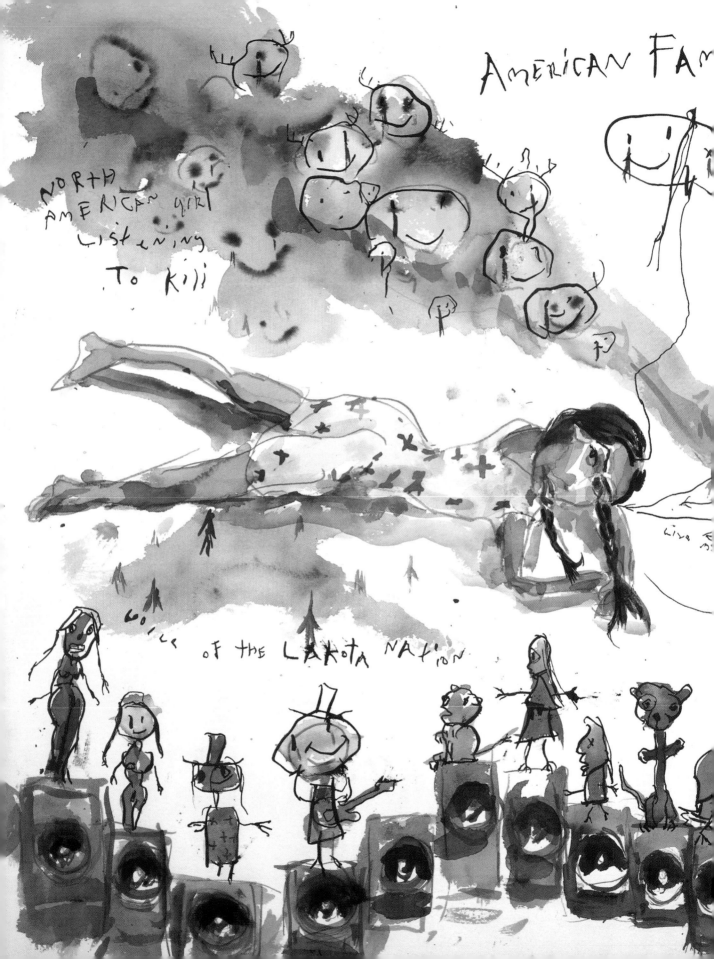

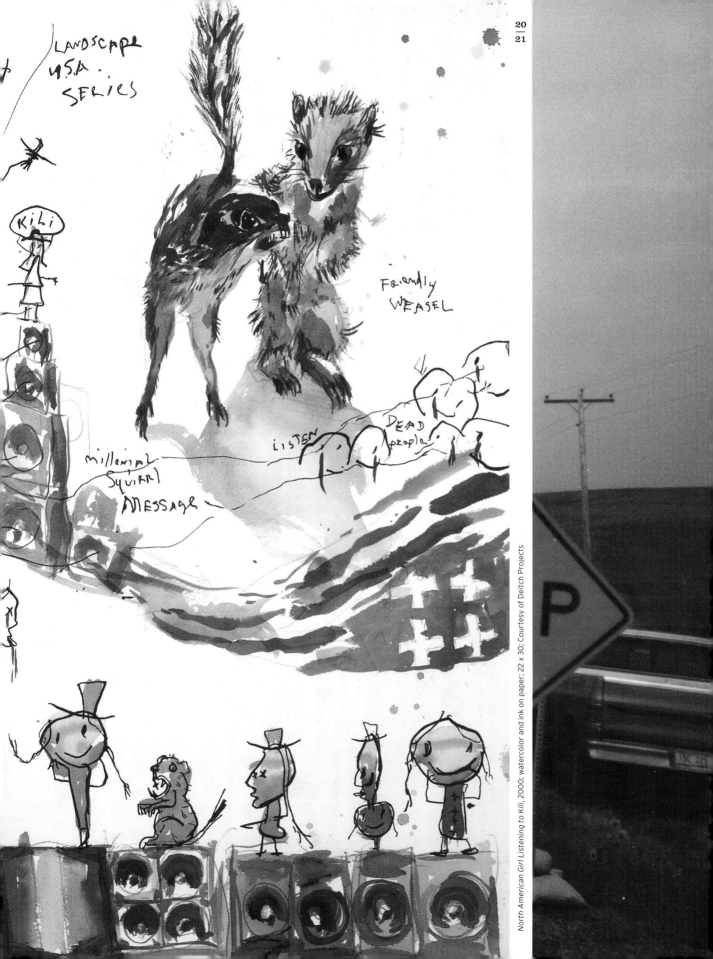

North American Girl Listening to Kili, 2000; watercolor and ink on paper; 22 x 30; Courtesy of Deitch Projects

Sacagawea + Friends USA, 2000; oil on canvas; 40 1/4 x 31; Courtesy of Deitch Projects

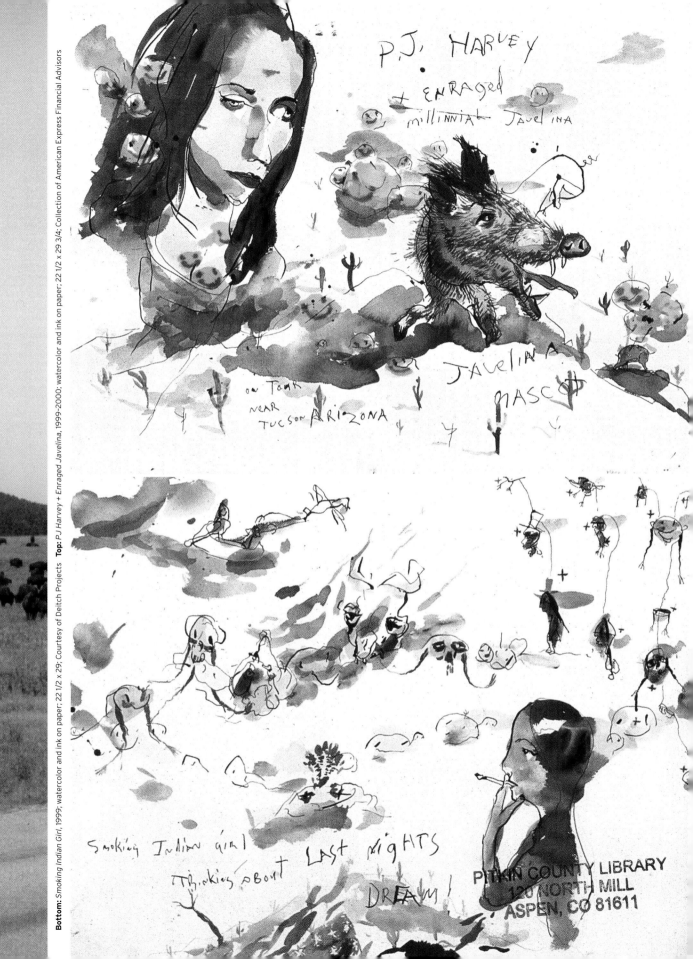

CRAWLING

NATIVE GIRL (US.)

AMERICAN FAMILY USA.

MISSYS DEAD DOG

ovde

Left: *Crawling Native Girl*, 2000; watercolor and ink on paper; 30 x 22; Courtesy of Deitch Projects Right: *Indigenous Rock Band w/ Enraged Javelina Mascot*, 1999; watercolor and ink on paper; 30 x 22; Collection of Nancy and Joel Portnoy

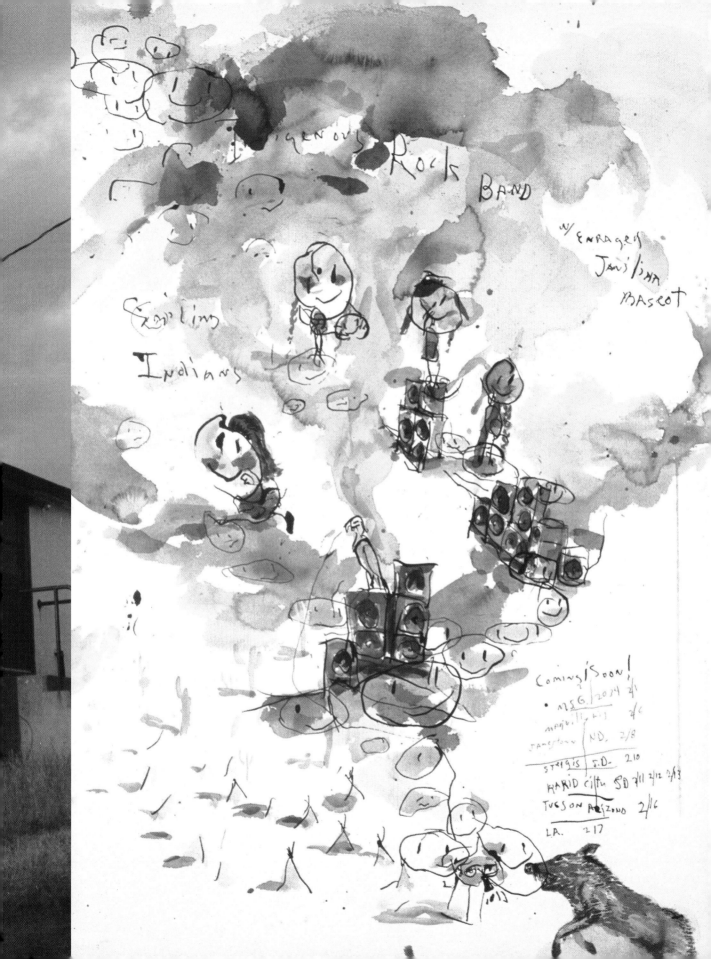

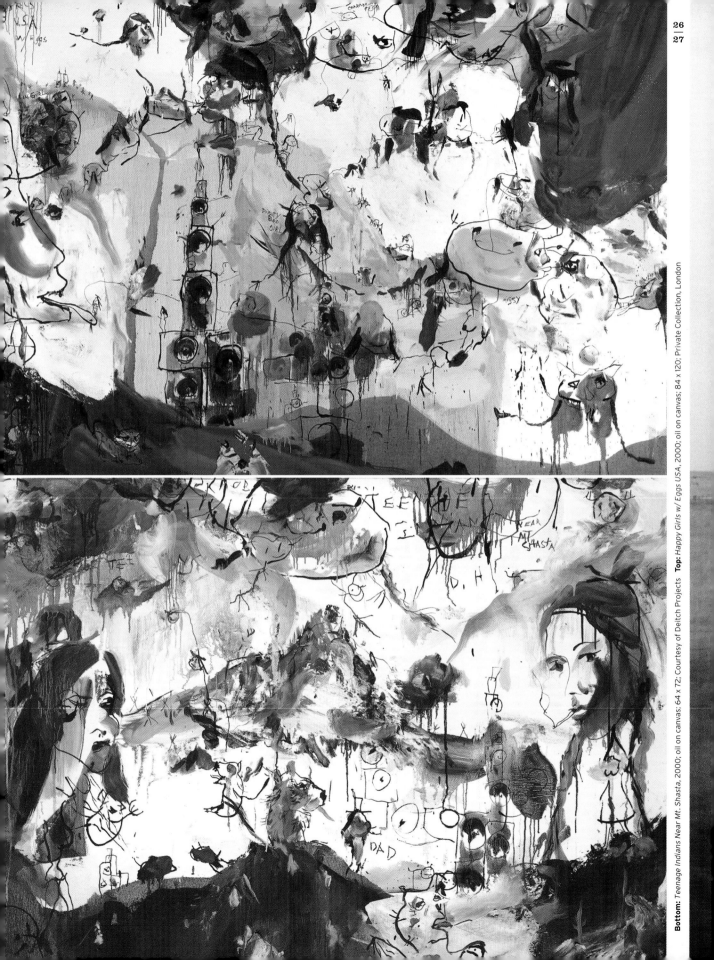

Bottom: *Teenage Indians Near Mt. Shasta*, 2000; oil on canvas; 64 x 72; Courtesy of Deitch Projects **Top:** *Happy Girls w/ Eggs USA*, 2000; oil on canvas; 84 x 120; Private Collection, London

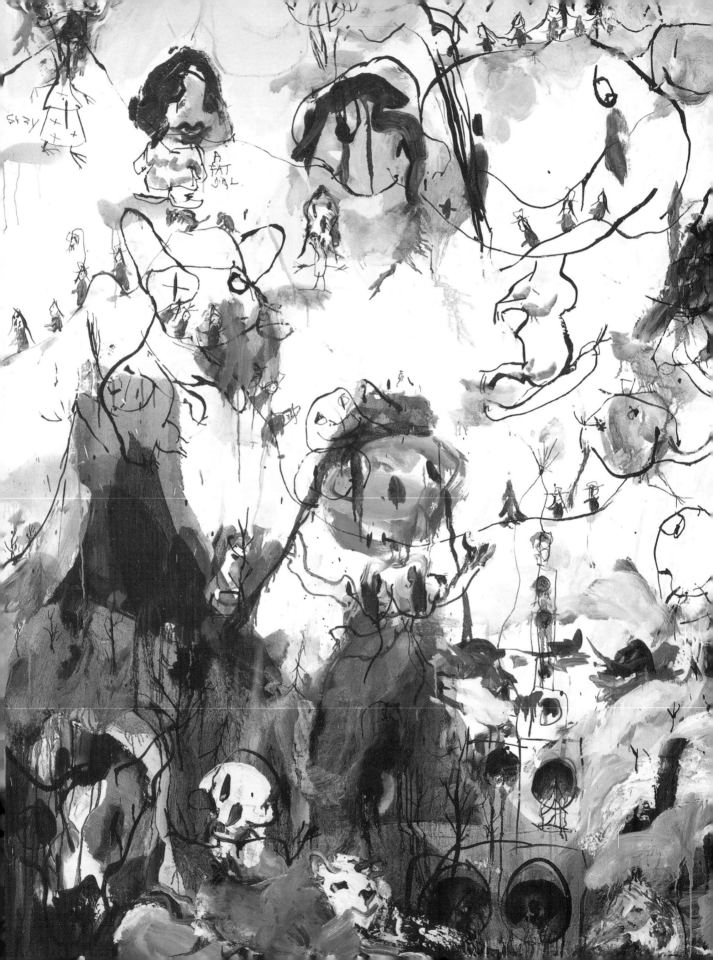

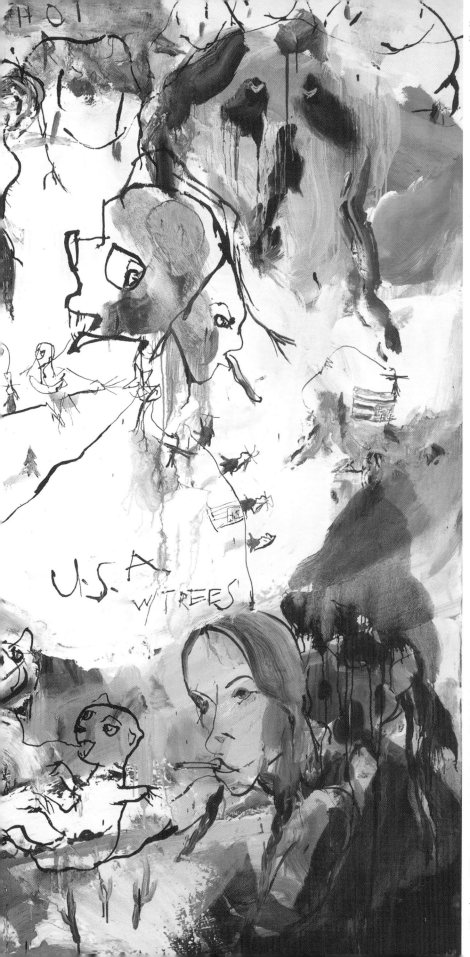

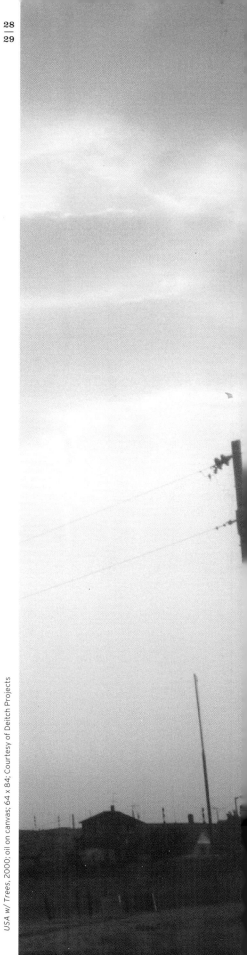

USA w/ Trees, 2000; oil on canvas; 64 x 84; Courtesy of Deitch Projects

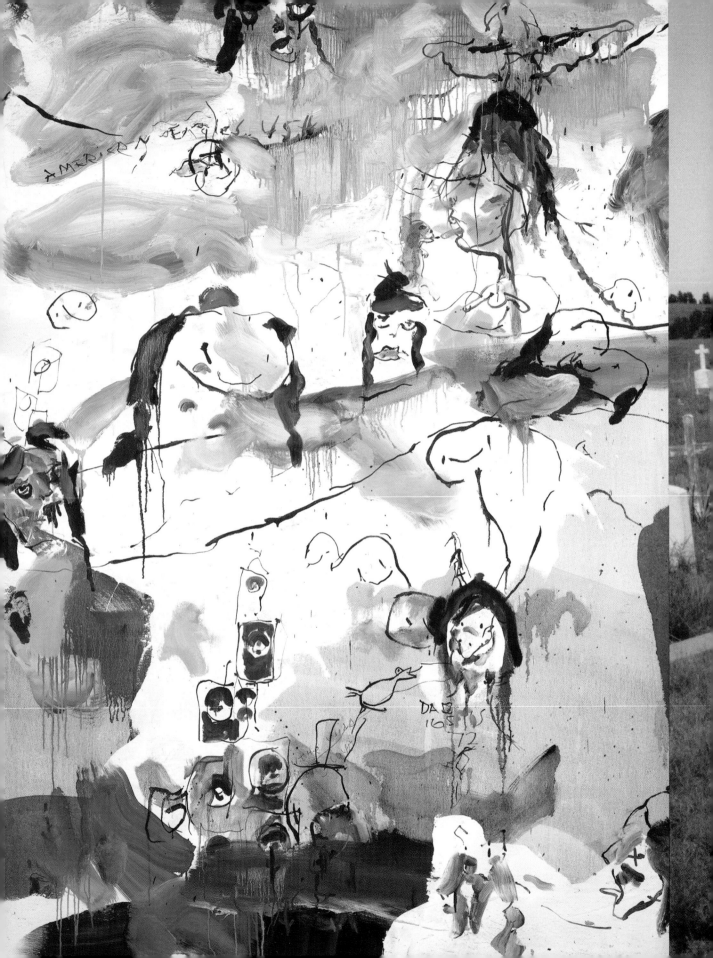

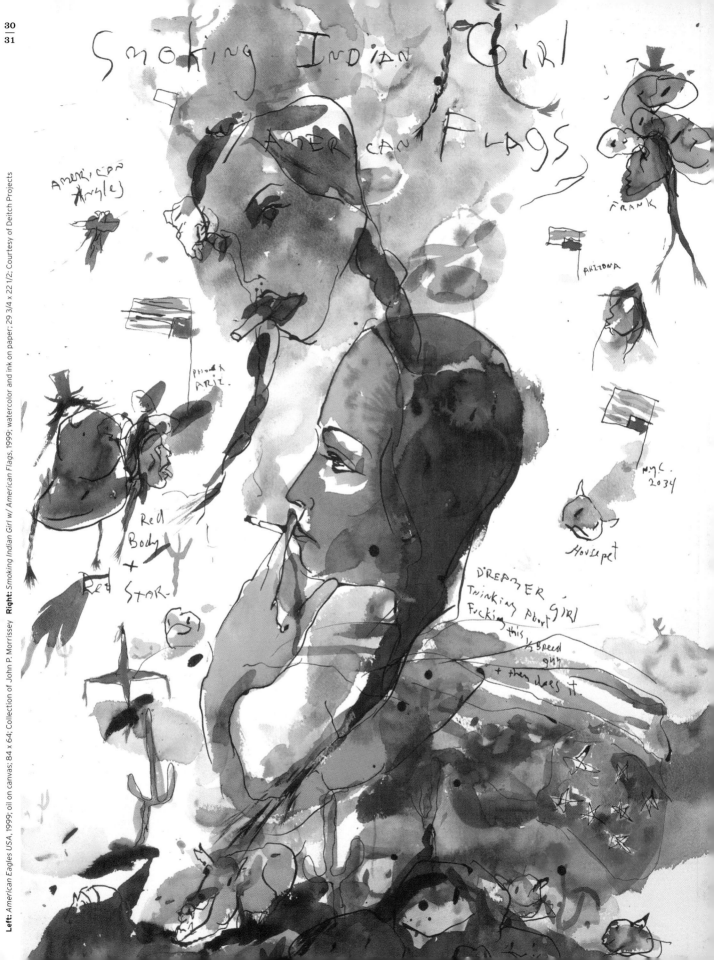

Left: *American Eagles USA*, 1999; oil on canvas; 84 x 64; Collection of John P. Morrissey **Right:** *Smoking Indian Girl w/ American Flags*, 1999; watercolor and ink on paper; 29 3/4 x 22 1/2; Courtesy of Deitch Projects

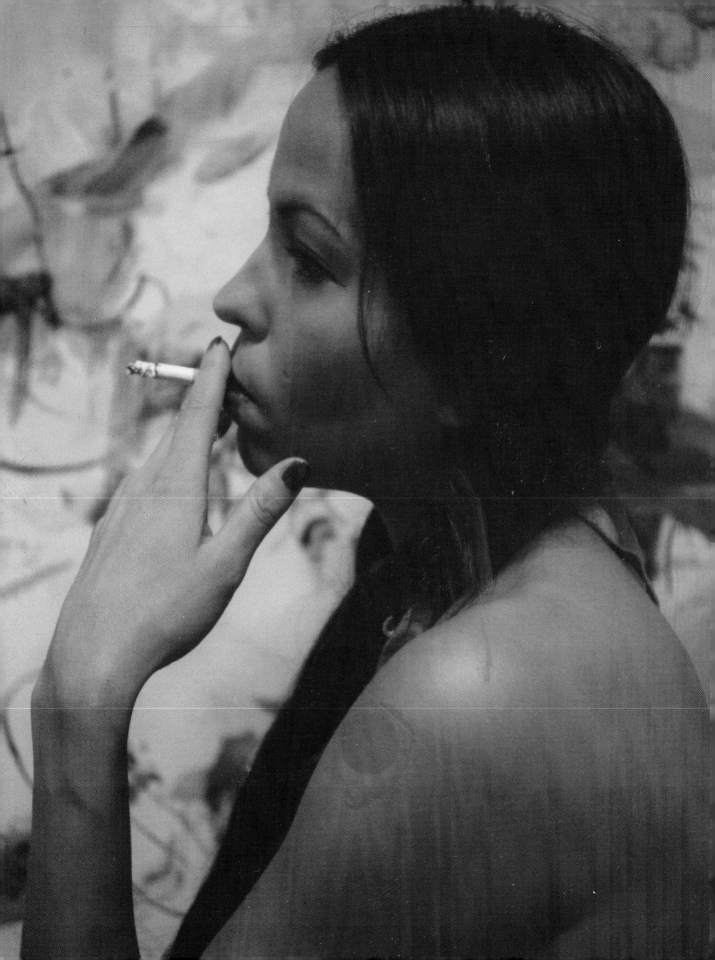

Foreword and Acknowledgments
Stephen Fleischman, Director, Madison Art Center and Dean Sobel, Director, Aspen Art Museum

It is a great pleasure for the Aspen Art Museum and Madison Art Center to present Brad Kahlhamer's first one-person museum exhibition. Kahlhamer's practice of infusing his paintings with a highly personal symbolism expressive of his American Indian heritage and a visual language characteristic of late modernism has resulted in an intelligent and powerful body of work. It is particularly fitting that our two institutions collaborate on this project. Although the artist has lived in New York since 1982, he still acknowledges the importance of (and his work continually attempts to reconcile) two fundamental aspects of his life—his deep-seated connection to the "West," where he was born, and his roots in Wisconsin, where he was raised and educated. It is an honor to bring his work to audiences in the two regions that have shaped his life so profoundly.

This project has been realized through the generosity of several funders. The organization of the exhibition and its Madison presentation have been made possible by a major grant from the Ameritech Foundation; a grant from the Dane County Cultural Affairs Commission with additional funds from the Madison Community Foundation and the Overture Foundation; The Art League of the Madison Art Center; the Exhibition Initiative Fund; the Madison Art Center's 2000–2001 Sustaining Benefactors; and a grant from the Wisconsin Arts Board with funds from the State of Wisconsin. The Aspen Art Museum presentation is sponsored by the AAM National Council, with additional support provided by Nancy and Robert Magoon.

We are grateful to the lenders who agreed to part with their works so they could be included in this exhibition: American Express Financial Advisors; ContemporaryArtProject, Seattle; Suzanne Geiss; John P. Morrissey; Neuberger Berman; Nancy and Joel Portnoy; Michael Steinberg; the Marc and Livia Straus Family Collection; Tom Wirtz; and a private collection, London. We would also like to acknowledge Jeffrey Deitch and Suzanne Geiss of Deitch Projects for their assistance throughout the exhibition. Sara Krajewski, Curator of Exhibitions at the Madison Art Center, conceived of the exhibition and worked closely with the artist on every facet of the project.

We would like to thank the Boards of Trustees at the Madison Art Center and the Aspen Art Museum for their terrific ongoing support. We are also indebted to the dedicated staffs at our respective institutions. At the Madison Art Center special recognition goes to Sheri Castelnuovo, Curator of Education; Dianne Steinbach, Director of Development and External Affairs; Michael Grant, Director of Public Information; Marilyn Sohi, Registrar; Jill Shaw, Curatorial Assistant; Mark Verstegen, Technical Services Supervisor, and his entire installation crew. In Aspen, Associate Director Mary Ann Igna, Education Coordinator Kat Parkin, Registrar Cathleen Murphy, and Preparator David Marsh were most closely involved in the preparations for this exhibition.

From the inception, the artist intended to vary the content of the exhibition at each venue. In this way, he can respond, not only to variances in the respective gallery spaces, but also to their distinct geographic locations. This catalogue documents the common ground between the two installations.

This publication is greatly enhanced through Sara Krajewski's essay; she has provided the most substantial study on Kahlhamer's body of work to date. We also appreciate the insightful essay on Kahlhamer's drawings by Laura Hoptman, Assistant Curator in the Department of Drawings at The Museum of Modern Art, New York. Deborah Littlejohn and Santiago Piedrafita designed this publication, which was thoughtfully edited by Mary Maher.

We reserve our final thanks for the artist. Brad Kahlhamer's close involvement in all aspects of this project has resulted in an exhibition and publication that more fully represent his unique vision.

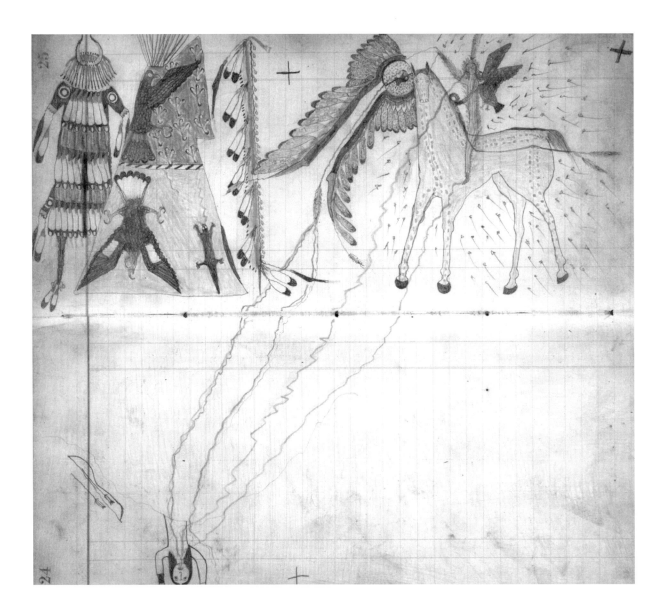

Henderson Ledger Artist A (Arapaho); *Medicine Vision*, 1882; pencil, colored pencil and ink; 12 x 7 1/2 ; Collection of Mr. and Mrs. Charles Diker; photograph courtesy of Mr. Charles Diker

The Good Yarn
Brad Kahlhamer's Recent Drawings
Laura Hoptman

The discipline of drawing is among the most flexible in the discourse of art, encompassing everything from cave painting, to architectural renderings, to laser projections. Two categories, however, are most often mentioned in any attempt at a definition: the notational—marks meant to serve as a trace of an action or a bodily activity—and the narrative.[1] Like all good drawing, the pen and gouache works of Brad Kahlhamer combine elements of both. His freewheeling swathes of translucent wash bring to mind the trails of emotional energy created by abstract expressionists like Jackson Pollock, and the calligraphic pictorial incident he uses to punctuate these color fields recalls the graffiti marks of Cy Twombly or the emphatic hieroglyphs of A.R. Penck and Jean Michel Basquiat. However much these clearly notational elements play a role in Kahlhamer's drawings, as in much of contemporary drawing produced by young artists over the past several years, it is the narrative element that is of prime importance in Kahlhamer's recent works on paper.

Over the past five years or so, Kahlhamer has developed a corps of characters, both human and animal. These include the Native Girl with two flying black braids and bright red smile, strong-featured, top-hatted Ugh Jr., and Lil' Brother, the half human Dog Boy, the prickly pig-snouted Javelina, the deceptively cute Prairie Dog and, some-times, the artist himself. These characters, along with a repeated repertoire of iconic props that include malleable yellow smiley faces, an upside-down American flag (the symbol of the American Indian Movement), and stacks of black rectangular amplifiers familiar to rock concert goers, are deployed in different settings that range from a park in the artist's hometown of Tucson to Bear Butte, a sacred site in South Dakota. Kahlhamer also is a painter and a musician, and his ensemble appears in both these genres as well, but it is in his drawings where they grow from mere motifs into key players in an ongoing story that is equal parts chronicle, fiction, and myth.

It has been observed that Kahlhamer's drawings share characteristics with native American ledger art (page 40), a kind of drawing produced most heavily by Plains Indian tribe members during their forced relocation onto reser-vations from approximately 1860 to 1900. Adopting non-traditional materials like the bound record books used by settlers and servicemen as well as colored pencils, aboriginal artists recorded battles, recounted the exploits of heroes mythic and actual, and documented social and religious events. Made at a time when Caucasian conquest and widespread mortality caused by war and disease called into question the efficacy of traditional oral history, ledger drawings served as concrete documentation of tribal history and customs. Faced with annihilation, native peoples used the drawings as conscious attempts to preserve aboriginal culture for future generations.[2]

Kahlhamer's graphic works seem to gather their inspiration from the peculiar hybridity of the ledger drawings.[3] In object as well as in practice, they represent cross-cultural communication between aboriginal peoples and American newcomers on a number of levels, beginning with the very tools they used to make the drawings. Highly prized from the outset by white collectors who traded for them, bought them, and took them as war booty, some ledger books were even drawn with sale or trade in mind. Created as communal histories of individual tribes, the ledger books became a means of intercultural storytelling when placed in the hands of those who understood neither the language nor the culture of the people that produced them. In the words of Anna Blume, these works of art held a "middle place" between the Caucasian and aboriginal worlds.[4]

Adopted by Caucasian parents as an infant but of native descent, Kahlhamer himself occupies an unusual inter-mediate position between the mainstream American, Caucasian, Christian culture where he was raised and the indigenous culture of his ancestors. Kahlhamer's drawings often incorporate specific devices he found in his own

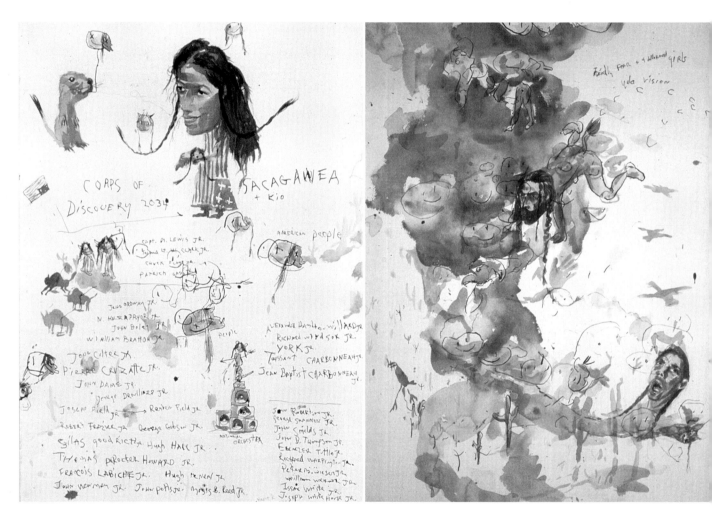

Left: *Corps of Discovery Sacagawea + Kid*, 1999-2000; watercolor and ink on paper: 29 3/4 x 22 1/2; Collection of American Express Financial Advisors

Right: *Friendly Fear + Four Deformed Girls*, 1999; watercolor and ink on paper; 29 3/4 x 22 1/2; Private collection, New York

close study of Plains Indian ledger work. For example, many ledger drawings include small, simply drawn pictures identified as "name glyphs" that are attached to larger pictures by spidery lines. Much like captions, these glyphs—which often take the form of iconic symbols of anything from an animal to an atmospheric state—identified the characters to which they were attached.

Kahlhamer has not only adopted this convention in his drawings, he has elaborated on its primary purpose of naming by using it as an ironic aside, or a sequencing device. In a drawing entitled *Corps of Discovery 2034 Sacagawea + Kid* (pages 10, 42), Kahlhamer presents a satirical updated portrait of the aboriginal guide responsible for Lewis and Clark's successful expedition up the Missouri River to the Pacific Ocean. Above the names of participants in the original 1804–06 expedition, a contemporary Sacajewea, draped in an upside-down American flag, holds out a tadpole-like blob whose ochre coloring and grossly exaggerated hairstyle mark it as a pint-sized version of Kahlhamer's "Native Girl" character. No longer an accomplice, but a militant who triumphantly displays the very native fruit of her sexual and political collaboration, "Sacagawea's" glyph is a smiley face—the international symbol of America's carefree if not stoned contentment—subversively crowned with the bangs and braids that mark all Kahlhamer's native American characters.

Baby Millenial Javelina (page 18) is a many-figured work from approximately the same period featuring, among other figures, a full-grown desert boar covered with thick and thorny hairs like a curry brush, confronting a newborn javelina, small, pink and ferocious. These two animals are at the center of a ring of figures that include two schematic profiles of native American men labeled "Happy Dad" and "Dead Dad," two javelina corpses dated 1955 and 1956, and a little cartoon character with a kitty-like face on spindly legs labeled "Mother." Linked to the small and large javelinas by a thin and wavering line that seems to crackle like an electric current, both the Mother figure and the multiple Dads share the animals as their glyphs. In this work, the lines of relationship are used not only to name characters, but also to define their relationships and, ultimately, tell a story. Each figure described is joined to another, creating a wheel-shaped diagram of associations that is at once a family tree and a pictographic fable of inter-generational conflict that culminates in a confrontation between old and young.[5]

The "middle place" of Plains Indian ledger drawings is embodied at the most fundamental level in the manner in which Kahlhamer blends his fascination with native American history and traditions, and his very real commitment to producing work reflective of the present time. Almost all the artist's motifs are drawn from his own personal history, including his friends, pets, favorite singers, and hometown sites. Taken from contemporary urban life, these characters operate in the space of myth, a place where a teen-age Indian Girl has a vision of the British rock singer P.J. Harvey on the top of Bear Butte, or Prairie Dog, Emissary from the Underworld, emerges from his lair on Flag Day to impart wisdom to a Vietnam vet.

Plains Indian ledger drawing is a central, conceptual influence on Kahlhamer's work on paper, an influence perhaps consciously acquired to place this body of work in a unique position between history and contemporaneity, and between aboriginal and European cultures. The look of Kahlhamer's drawings, that is, the way they are drawn, has little to do, however, with the style of most Plains Indian ledger work but rather makes reference to quite another American graphic legacy, comic art. An art director at Topps Chewing Gum for ten years, Kahlhamer had the chance to study a huge range of comic styles. His familiarity with the symbolic language and conventions of comic book illustration is evident throughout his drawings, from the use of Xs instead of eyes to indicate a dead figure to anthropomorphization of certain animal characters who stand upright on spindly legs, sport human hairstyles, and wear suits or top hats. In some works, the ubiquitous smiley face exudes from the mouth of a character recalling both the Plains Indian convention of illustrating the spirit and the comic book device of the thought or word bubble. Kahlhamer's most recent drawings are less likely to refer to cartoons than the style of dramatic comic

serials that sustain a story line and eschew a simple iconic image for a highly finished chiaroscuro rendering of individualized characters who make repeat appearances. In these works, figures are more detailed, commanding a three-dimensional space that expands perspectively to meet their needs. In contradistinction to the loose, all-over composition of earlier drawings, the newest ones have more tightly rendered layouts where individual sheets are divided into zones of time and activity, a practice that recalls the organization of a comic book panel.

At the center of *Smoking Indian Girl w/ American Flags* (page 31), a girl is depicted as if in cinematic close-up, ruminatively smoking a cigarette like a *noir*ish comic book heroine, producing a blue puff of smoke from her ciga-rette in the midst of which floats another smoking "Indian Girl." The smoke cloud serves as a kind of thought bubble, a pure comics' convention that allows dreams, fantasies, or visions of past and future to float alongside, above, or behind the figure who generates them. Kahlhamer uses this split-panel effect to juxtapose chronological as well as psychic states. In *Floating PJ Harvey and Teenage Native Girl*, the singer is the product of a vision the Native Girl is experiencing, as indicated by the former's elevated state and the latter's otherworldly expression. In the gutter between the two images hovers Bear Butte, the site of centuries of Lakota sacred visions, capped by a whirlwind of blue smoke we recognize from *Smoking Indian Girl* as an indicator that spiritual materializations are indeed afoot.

In another recent drawing (page 42), the carefully shaded, fully rendered head of a native American man, head tilted back, mouth open wide as if in speech or song, appears in the lower right-hand corner. Identified by neither glyph nor caption, it is a self-portrait of the artist, narrator of the action, author/recipient of the visions that dance above him on the page. For Kahlhamer, drawing is the means by which to both construct a narrative and to create his own history, an activity closer to the ritual of storytelling than to recording. Taken together, Kahlhamer's works on paper tell a tale that marries the historical and the contemporary, the spiritual and the quotidian. Above all, it is a tale in which the trajectory is not mapped in advance nor the conclusion forgone, but one that is ongoing, shaped by the artist's experience and inspired by his imagination.

1. These categories are not exclusive of one another; a series of traces can describe a narrative and a highly finished composition can serve as a record.

2. It is interesting to note, as has Janet Catherine Berlo in *Plains Indian Drawings 1865–1935: Pages From A Visual History* (New York: Harry N. Abrams, Inc., 1996), that by the 1930s aboriginal artists were being commissioned by anthropologists to make drawings of specific tribal religious and social practices so they could be studied.

3. See *Drawing and Being Drawn In: The Late Nineteenth Century Plains Graphic Artist and the Intercultural Encounter*, in op. cit. p. 13.

4. Anna Blume, "In Place of Writing," in op. cit. p. 40.

5. According to the artist, this work represents his imagined family history based on the scarce information he has managed to obtain about his birth; he was born in 1956 to a mother whose identity he does not know and a father who, presumably, had died.

I like to drive
To visit tall trees
I like to drive
Bring my windshield to the bees

You don't have to go real far
Just climb up on top of my car
Stretched out in midday sun
In our dreams, we'll pass everyone[1]

How I got here was not easy
This thin red figure who is he
I know her name but I don't have a picture
She came to Tucson gave birth to my future[4]

I Like to Drive
Transport and Transformation in Brad Kahlhamer's Paintings
Sara Krajewski

... twangs Brad Kahlhamer on the opening track of his CD, *KTNN*. The song reveals much about the character of the artist, a spiritual nomad who pursues knowledge on the road and in the studio. For Kahlhamer, the transforming energy of imaginative and actual transport occasions an exploration of the power that exists in one's self, in history, and in the natural landscape. He strives to achieve release into an imagined place where his own experience meshes with history and dream. The lyrics of his songs, snapshots from his travels, and his revelatory paintings all give body to this searching spirit.

Kahlhamer's biography is central to the discussion of his art. Born in 1956 in Tucson, Arizona, Kahlhamer was put up for adoption. Adopted by a white family of German descent, he grew up without knowledge of his tribal affiliation. "(My work) is all about what I call the third place," he explains. "I'm adopted so there was another life available to me which might have been on a reservation or with my natural parents, whom I've yet to find. Then there's the life that I've lived, which is the adopted life. The third life is melding these first two lives with lots of fantasy, and that's what many of my paintings are about. It's this combination of history, fantasy and personal revelation."[2]

Among his first exposures to art, Kahlhamer lists paint-by-numbers sets and Tucson painter Ted de Grazia, best known for kitschy collectibles that portray native Americans. Years later, in college in Wisconsin, he was drawn to painting and experimented with portraiture, abstract figuration, and expressionism. But Kahlhamer maintains that pop culture—music, album covers, comics, and cartoons—has had more impact on his artistic development. Travel proved influential, too. Playing in rock bands during and after college, Kahlhamer traveled throughout the Midwest. On the road over several years, he often felt a "weird otherness"[3] in both new and familiar environments which suggests an uncanny reaction or intuitive connection to particular landscapes. Kahlhamer settled in New York City in 1982 and accepted a design position at Topps Chewing Gum. There he built upon a familiarity with the power of comics' visual narratives while working alongside the intense personalities of cartoonists, under-recognized underdogs among artists. Such life experiences permeate Kahlhamer's paintings today. Seeking to express an ongoing exploration of his ethnicity and self, he has developed a divergent visual language of pop culture references, native American traditions, and the marks and color of modern abstract painting.

Frequent personal trips to the southwestern United States in the 1990s fueled a series of paintings about travel; the act of being in a transitory state is an apt metaphor for Kahlhamer's cultural in-betweenness. In *65 MPH* (page 48) from 1996, the title inscribed at the top edge designates the speed of freeway travel. The letters "NM" above it indicate a location—New Mexico—further denoted by cacti, each one described simply with two brushstrokes. Kahlhamer's thick blocks of pink, gold, and sage paint also conjure up the atmosphere of the desert. The smeared application suggests a blurred, ever-changing view of the land through the windows of a speeding car. This captured moment offers a glimpse at a landscape physically transformed by human intervention and optically changed by the speed of the observer.

Where *65 MPH* remains grounded through form and color to a type of landscape, *10,000 FT* (page 50) is dislocated. Linear, non-representational marks contrast with a few specific natural forms but, overall, the lines and color splashes do not form into clear signs that identify a place. Rather, the title suggests such vantage points as mountain peaks or an airplane window that make the view of distant surroundings abstract. Hints made at elevated sites, like buttes, and actions, like flying, connote spiritual quests and freedom from the bounds of the earth.

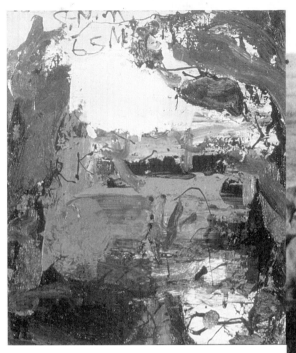

65 MPH, 1996; oil on canvas; 16 x 14; Courtesy of the artist

Saw your picture in a history book
Lying there frozen a permanent look
Shot left for dead a hundred years ago
In the red and pink snow[7]

A trip through the Plains states in 1998 precipitated a transition in Kahlhamer's approach to the symbolic potential of landscape. Along this journey, he visited sites linked to native American spiritual traditions and often felt overcome by their power. A particularly moving personal transformation took place at Bear Butte in South Dakota.[5] Returning to his New York studio after that trip, Kahlhamer began a series of large-scale paintings of expansive landscapes transformed by his own dreams and visions. This series of canvases addresses the past, present, and future of the West through the spiritual potency the land holds for native peoples. In many respects, the paintings speak of basic principles of native American cosmology: holism, animism, and human connection to natural and supernatural phenomena.[6]

At sacred sites, Kahlhamer opened his imagination to spiritual visions. He then adjusted his technical and formal vocabulary to transpose these revelations as fantastic stories. In contrast to what he termed his "gunked up and closed, non communicative" prior body of work, the canvases show a deeper pictorial space highlighted by washes of bright primary colors. The paint's transparency creates an appropriately hazy dream atmosphere. Kahlhamer sets his scenes in places he's visited—like Bear Butte, which he depicts as a sand colored, flat-top mountain—populating them with recurring characters that stand in for himself, those close to him, and historical figures. Each character has distinct traits and often is identified through an inscription. Kahlhamer employs this iconography extensively and, by recognizing these repeated signs, viewers gain access into each episode.

Junior and Missy American Eagles (page 7) relates the vision of a peaceful future of great possibility as Ugh, Jr., (the artist's alter ego) and a companion face the sublime vastness of the American West. Behind them rises the urban East, where Kahlhamer lives now, indicated by a tower of guitar amps that serve both as a personal reference and a kind of skyscraper. A disembodied Ugh floats high above the ground accompanied by spirits with braided black hair. The harmony of colors in this work imbues the scene with a sense of hopefulness. Kahlhamer ascribes properties to his palette: blue is sky, wind, and velocity; brown and red are earth and flesh; yellow is understanding; black is the East; transparency points to openness, change, and possibility. Inscribed along the top edge of the canvas is the number "2035." Read as a date, it indicates future and opportunity. Kahlhamer frequently commingles past, present, and future in his work.

Like many before him, Kahlhamer set out for the West to explore and record the frontier from his own perspective. He draws an ironic parallel to his journey with that of the legendary Lewis and Clark. *Loser + Clark* (page 8) presents a mental landscape unimaginable to those early 19th-century explorers yet one provoked by their legacy. Red, white, and blue predominate in this work, signifying the artist's own version of the American flag made from sky, water, earth and, arguably in this case, blood. Amplifiers indicate Kahlhamer the musician's presence, as well as sound and force, in this chaotic dream. Again resembling skyscrapers, the towering amps speak of East Coast-inspired urban development overtaking the green landscape of the West—a modern-day remnant of Anglo-American manifest destiny. A chorus of ghostly faces with braided black hair contributes further to the ominous mood.

Yet into such a disturbing image, Kahlhamer injects satirical humor. To start with, the painting's title clearly disrespects President Jefferson's emissaries who charted the American West. Camouflaged within the painting are bright yellow happy faces, those iconic well-wishers who extol us to "have a nice day." For Kahlhamer, these ubiquitous signs from popular culture reflect straight-up happiness and a prevailing sense of optimism. They also act as a visual hook that grabs the viewer's attention. As the artist explains, "people understand smiley faces and popular music but they don't really understand, or they're not interested in, the history of America or the history that…I think is important. So it's a way to meld all these things together and to make a solid painting that could be read abstractly and in a narrative way."

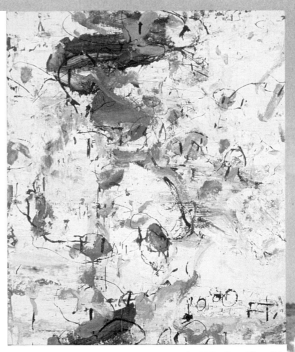

10,000 FT, 1996; oil on canvas; 50 x 44; Courtesy of the artist

Dark blue hair tied up in knots
A pierced tongue, fingernails with dots
I saw the star on a pony's flank
Years ago near a dirty lake
Red star on a young girl's face
All in all not out of place [9]

As abstractions, the paintings tap into the nearly universal concept of abstract art as the vehicle to express physical transformation and spiritual transport. Akin to Kahlhamer's work, German expressionists appeal directly to the viewer's subjectivity through distorted forms and bold colors designed to evoke emotion rather than describe the visible world. Some, like Wassily Kandinsky, move toward non-representation, assigning rapturous potential to certain colors and forms. Among modern native American artists, Oscar Howe, a Yanktonai Sioux painter working in the mid-20th century, mixes cubism, color field abstraction, and figuration to express Sioux cosmology. Howe once wrote, "What I hope to accomplish in my painting is satisfaction in content and form with completeness and clarity of expression and to objectify the truths in Dakota culture and present them in an artistic way."[8]

Abstract expressionism also befits Kahlhamer's less analytical and decidedly more intuitive approach. On the surface, his work shares the psychic charge and impulsive practice of the so-called drip painting of Jackson Pollock, which some argue is the direct, visual expression of the creative unconscious mind. But Kahlhamer is selective in forming his vocabulary of forms and references. Ultimately, he challenges the tenets of America's canonical modern art and its lionized white male practitioners: Pollock, Willem De Kooning, and others. In discussing the "first serious painting I was exposed to," Kahlhamer remarks, "I naturally started painting in this way, but now that I still continue to, I realized there's a whole other issue to painting in this American 'Ab Ex' style. This is sort of cartooning what's readily identifiable as American serious painting, to adapt that and put a Native net over it, or grid, or off the grid, is interesting for me...to tweak that language."

Kahlhamer confounds the pure self-reflexivity of high modernism by slipping in figures, landscape forms, and symbols from pop culture to cue the narrative. The washes of color and linear sketches of *Big Happy Family USA* (page 7) first catch the eye. Slowly, the ecstatic dream-narrative reveals itself through floating happy faces with braids, vignettes of human and animal characters, and other recognizable symbols like the stacked amplifiers, teepees, and canoes. Despite the signs that lead us into the story, by abstracting the characteristics of real people and places into evocative forms, the artist captures a hallucinatory experience where images, events, and time are compressed and distorted. Kahlhamer's work provocatively wavers between relating the story and relating moments of emotional or psychological transmutation.

Music presents a similar state to countless consumers of popular culture every day. It transports the imagination as it works directly upon the psyche. Kahlhamer's most recently composed songs have a country flavor, a roots-rock style textured through the sounds of cello, dobro, and occasionally a twangy jaw harp.[10] Like his paintings, each song tells a story that connects the personal and the historical, in this case, using that most universal language of popular culture, the rock song. His pursuits in both artistic genres are inextricable. As he says, "[t]he music is really more out of a pop world. The paintings come after the fact. I could write a song lyric and then I might add part of the lyrics to a painting and that would become the painting title. In a way it's like illustrating a song or writing a kid's storybook, where the song becomes a story and then paintings illustrate or tell that story."[11] Kahlhamer also is an avid listener, drawn to storytellers of a kindred spirit who are in touch with a darker side of American life. He is attracted to such diverse work as pow wow music, the rap of Tupac Shakur, and the folk of Steve Earle. As music inspires a listener's visual imagination, Kahlhamer's paintings intone an aural resonance to the mind's ear. *Little War Pony* (page 11) communicates a frenzied life-and-death struggle, authenticated by a scrawled inscription, ghoulish smiley-face skulls, and washes of red paint that suggest freshly spilled blood. The composition establishes a rhythm akin to the surging bass, urgent guitar, and the shouted lyrics of class revolution heard from Rage Against the Machine and the repeated exhortations and alternating shrill and melodic lines of Public Enemy's raps of racial uprising. Both groups are of particular interest to Kahlhamer. [12]

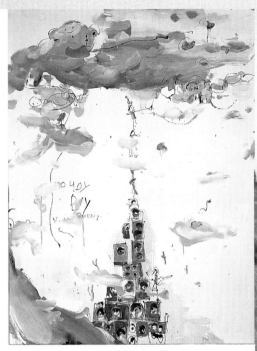

Cloudy Boy Monument, 1999; oil on canvas; 84 x 64; Neuberger Berman Collection

In a different vein *Cloudy Boy Monument* (pages 12, 52) is a quiet painting with an elegant balance of spare form—the central triangle of amps—and color—deep blue and spare white. The ethereal atmosphere that results finds a complement in the soulful, subtle guitar of Chris Whitley whose moody, mesmerizing songs relate narratives of an enigmatic, personal nature.[13]

Kahlhamer slips between genres easily, from painting to storytelling to pop music, finding the most powerful combinative language to express his stories of transformation. In a sense, he becomes a cultural subversive through his unique in-betweenness. He sees a kind of power in American culture and dismantles its elitism through his adaptation of the very forms associated with that power, such as abstraction in modernist painting and the rebellious guise of rock music. Like a wolf in sheep's clothing, the artist sneaks into the canonical hierarchy by adopting their forms and then, once in, reveals his true nature to the insiders. Whether or not the revelation brings about enlightenment, he leaves up to them.

Kahlhamer's paintings and songs take us, insiders and outsiders alike, to the real and imagined places he has been. Once there, we enter a larger discourse on the present and future position of native Americans in American society. Asked whether his work is political, Kahlhamer shies from the label but willingly admits a level of criticality is implicit in his strategy of inclusion. The under-representation of American Indians in current discussions of culture and society belie their considerable activity as musicians, writers, and artists. Speaking of this disparity and the significance of such discussions, Kahlhamer stresses, "for me, it's just important to be there."

1. Brad Kahlhamer, "I Like to Drive" from *KTNN*, A Full Pelt/BKG Production compact disc, 1998.

2. Laura Hoptman and Brad Kahlhamer in *Interview*, October 1999, p. 36.

3. Quotes are from the author's discussion with the artist in July 2000 unless otherwise noted.

4. Kahlhamer, "Dark Hair" from *KTNN*.

5. Bear Butte is a sandstone formation in the Black Hills of South Dakota. It is a sacred site for Lakota and Cheyenne tribes, associated with prayers and vision quests where men may invoke visions through prayer, fasting, smoking, and sleep deprivation.

6. See Paul H. Carlson, "Ceremonies and Belief Systems," in *The Plains Indians,* (College Station: Texas A&M University, 1998).

7. Kahlhamer, "Blackbirds" from *KTNN*.

8. "New Indian Painting," from the Heard Museum Resource Guide, www.heard.org/education/resource/nip.html, 1997. Many other native American artists engaged European and American modernism in their work as they sought to express spirituality. See also Margaret Archuleta and Rennard Strickland, *Shared Visions: Native American Painters and Sculptors in the Twentieth Century,* (Phoenix: the Heard Museum, 1991).

9. Kahlhamer, "Red Star" from *KTNN*.

10. On *KTNN*, Kahlhamer was joined by Scott Hill on guitar, Jane Scarpantoni on cello, Kevin Sparke on percussion and jaw harp. Hill and Kahlhamer also play together as El Niño.

11. Margaret Archuleta and Brad Kahlhamer in *Brad Kahlhamer: Friendly Frontier* (Deitch Projects: New York, 1999), n.p.

12. Rage Against the Machine's latest release is *The Battle of Los Angeles* (1999, Epic Records). Among Public Enemy's acclaimed recordings are *It Takes a Nation of Millions to Hold Us Back* (1988, Def Jam) and *Fear of a Black Planet* (1990, Def Jam).

13. Chris Whitley's recent recordings include 1998s *Dirt Floor* (Messenger) and 2000s *Perfect Day* (Valley).

Left: Handmade doll, 2000; mixed media; dimensions variable; Collection of the artist Right: Handmade doll, 2000; mixed media; dimensions variable; Collection of the artist

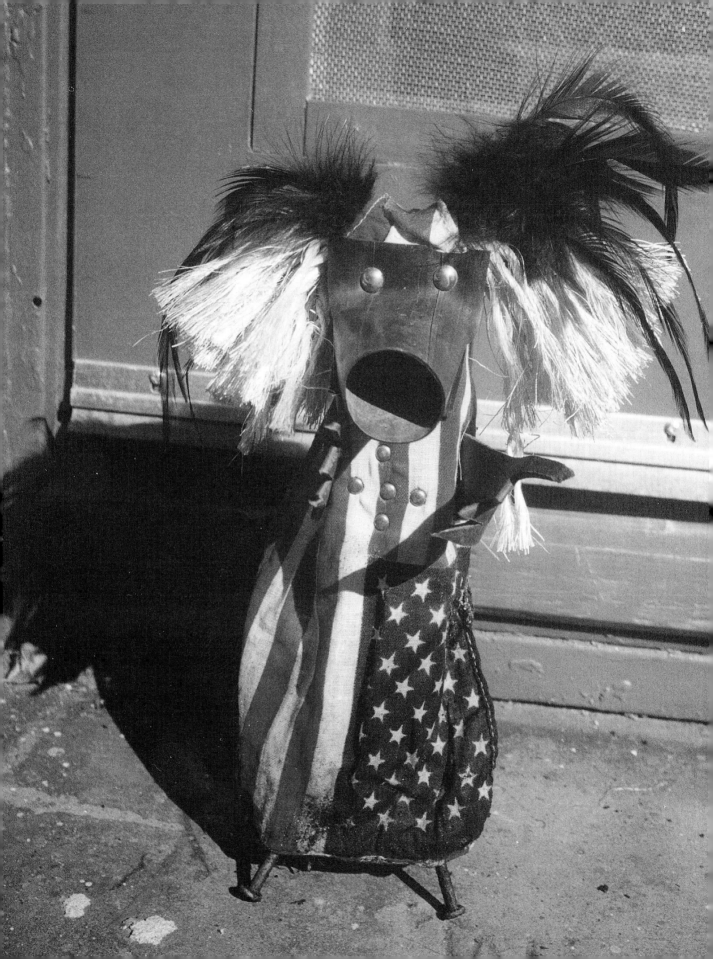

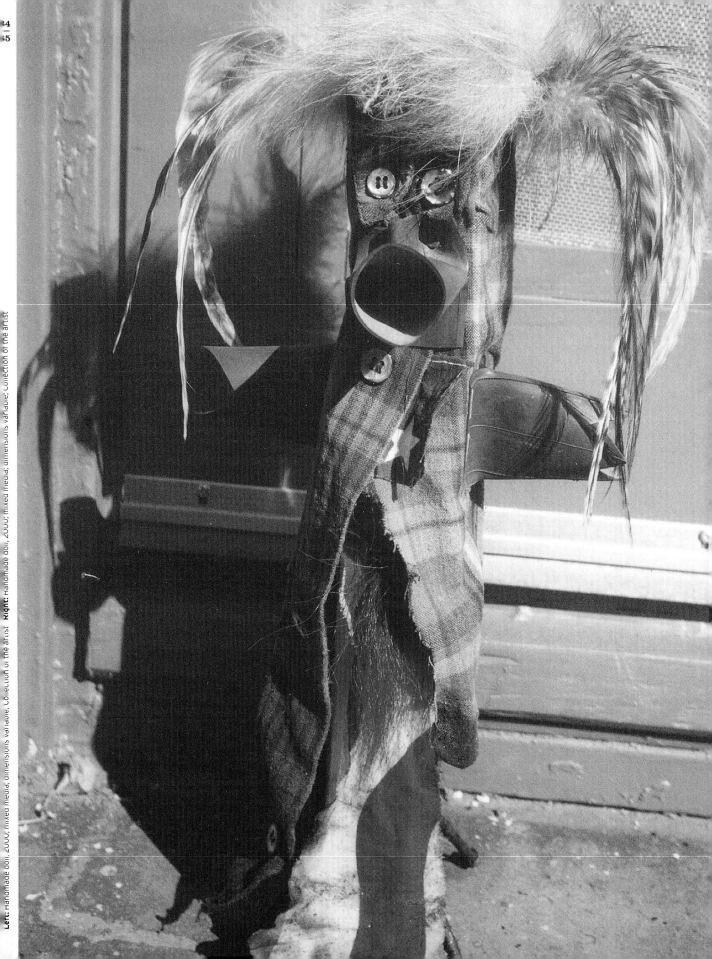

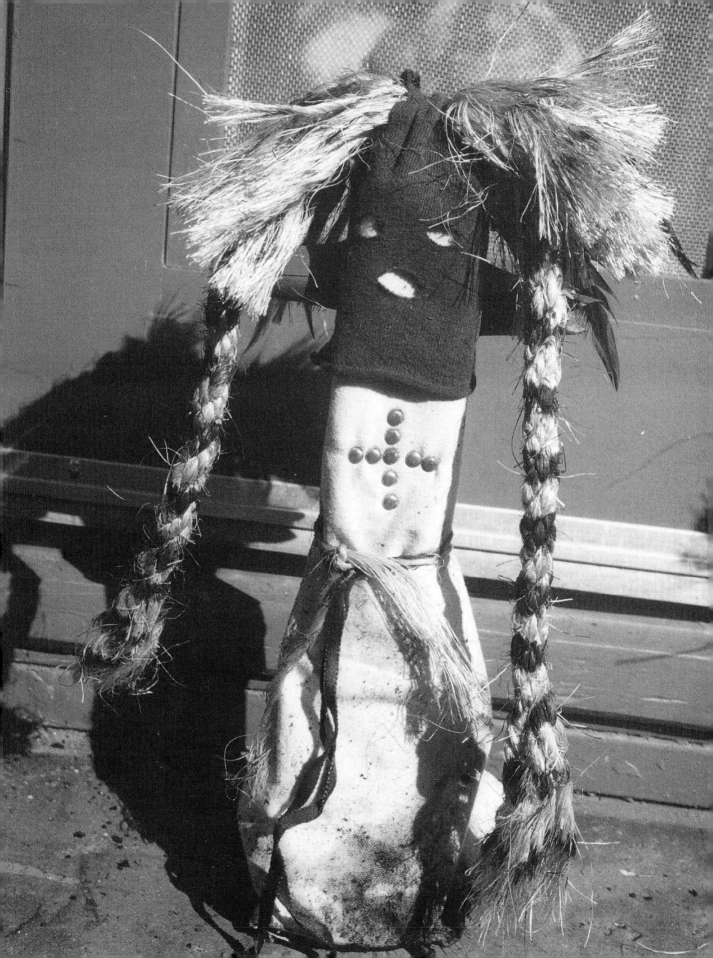

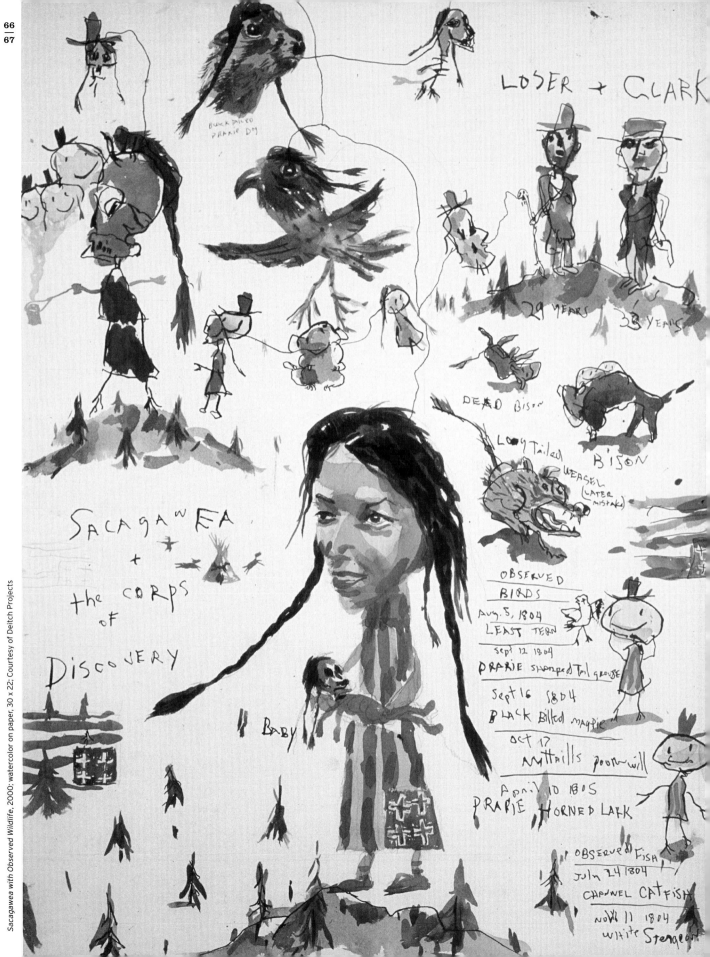

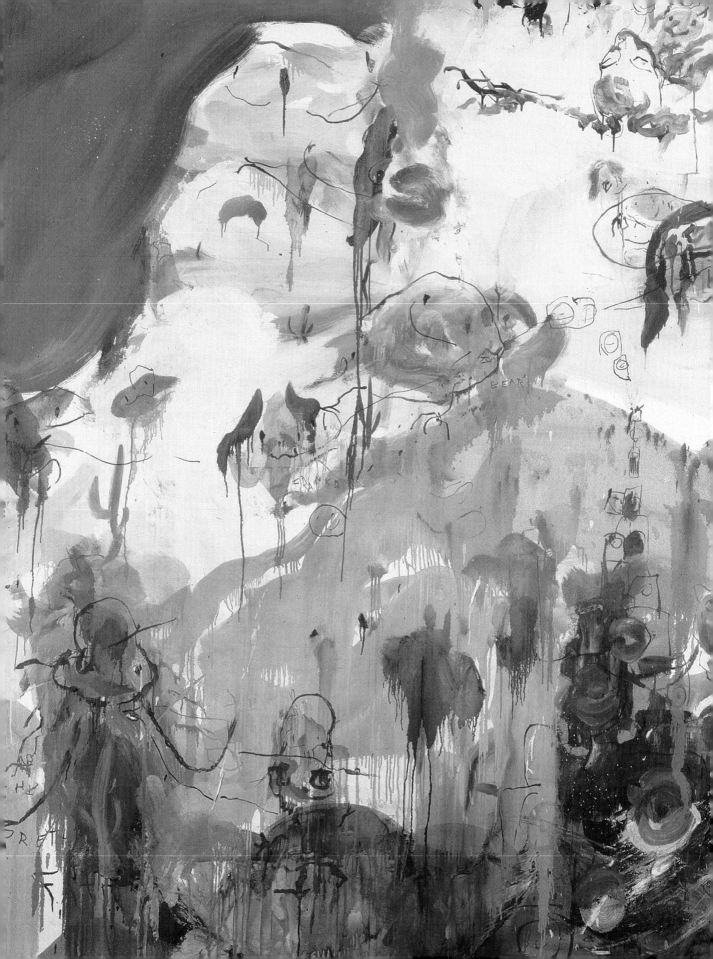

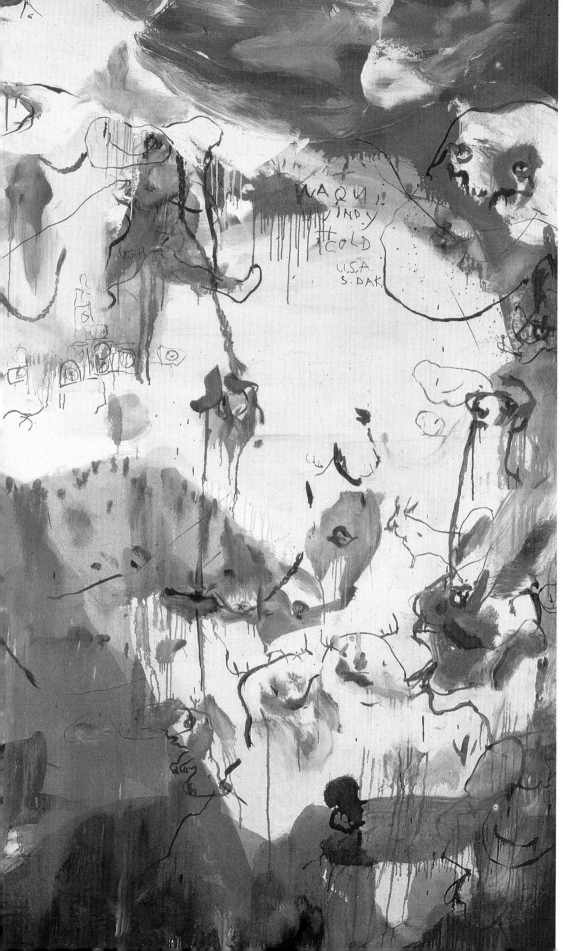

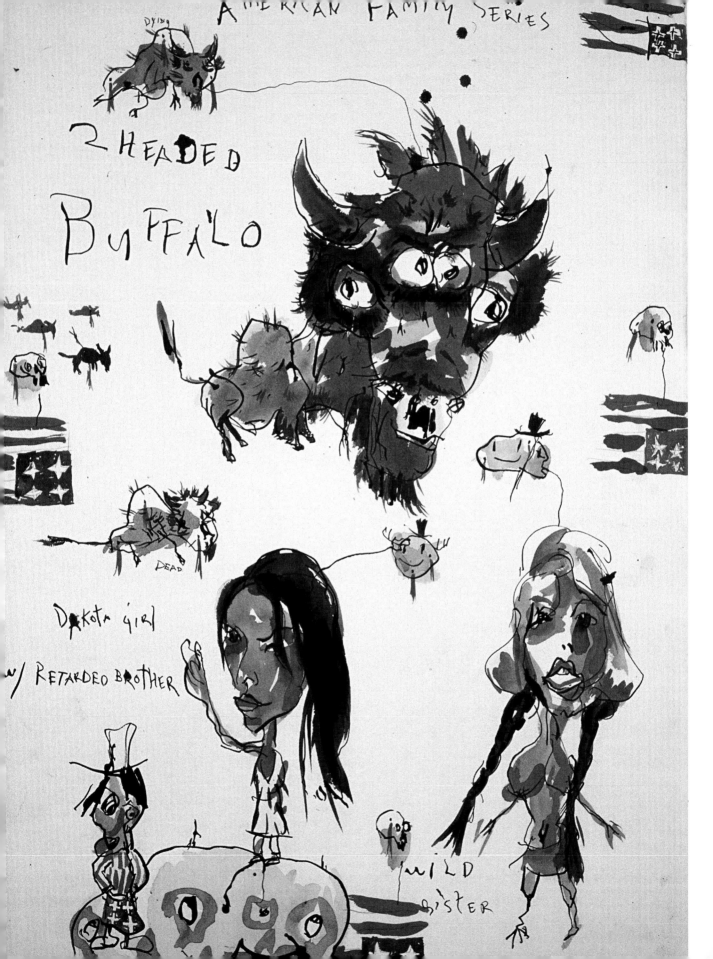

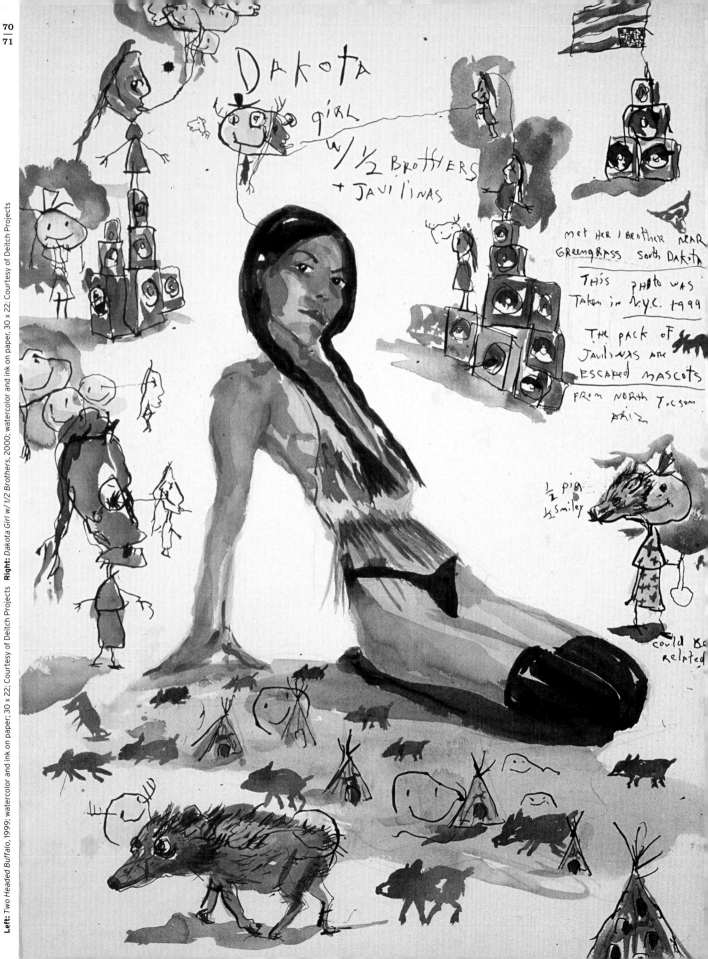

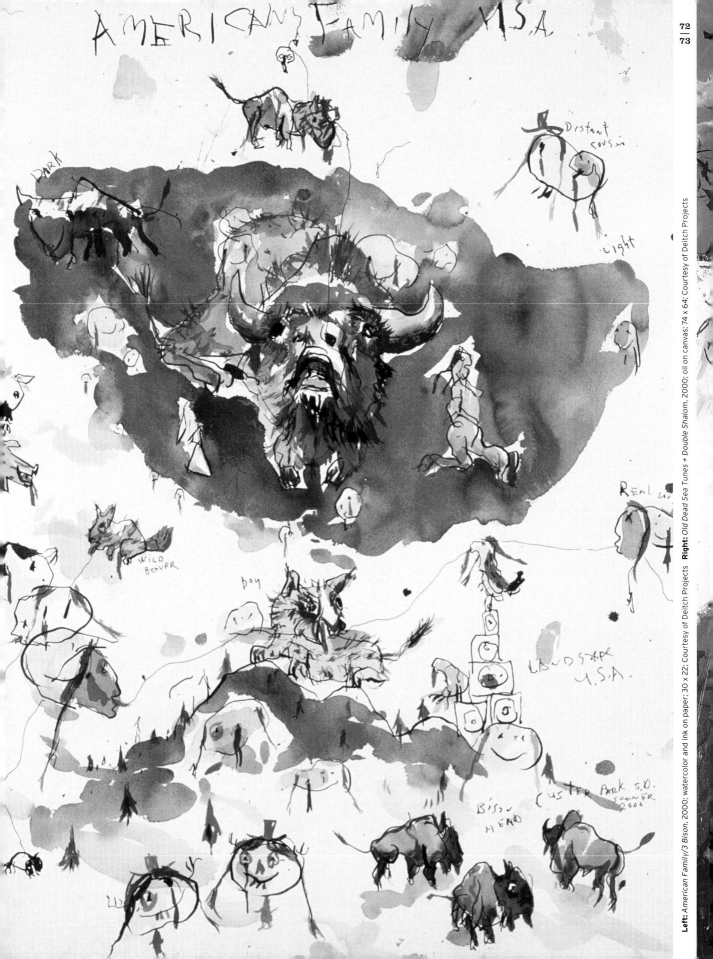

Left: *American Family/3 Bison*, 2000; watercolor and ink on paper; 30 x 22; Courtesy of Deitch Projects **Right:** *Old Dead Sea Tunes + Double Shalom*, 2000; oil on canvas; 74 x 64; Courtesy of Deitch Projects

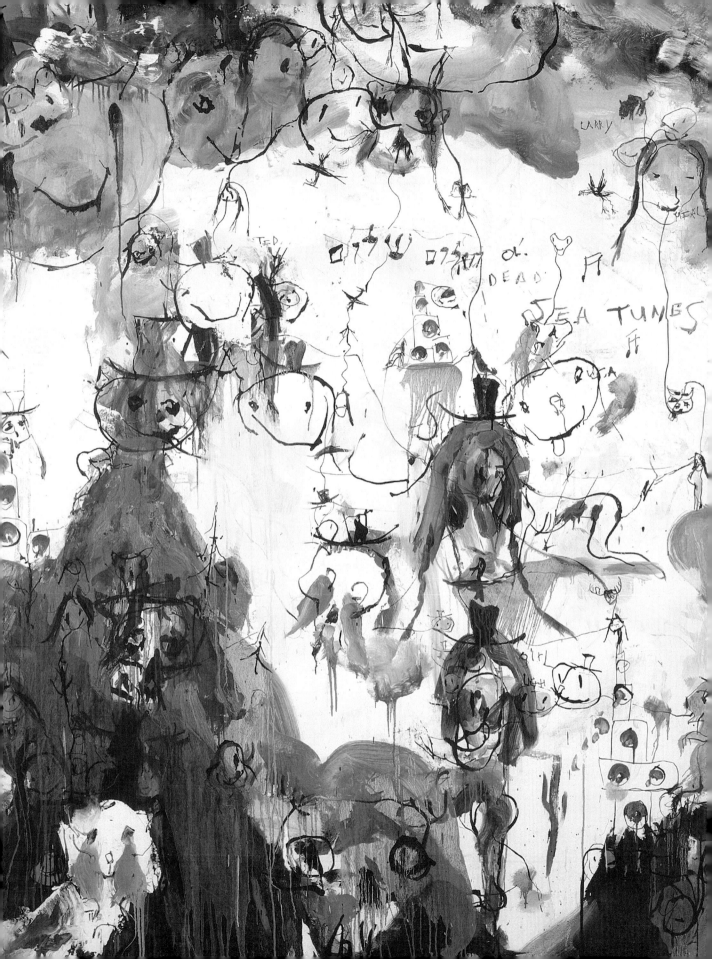

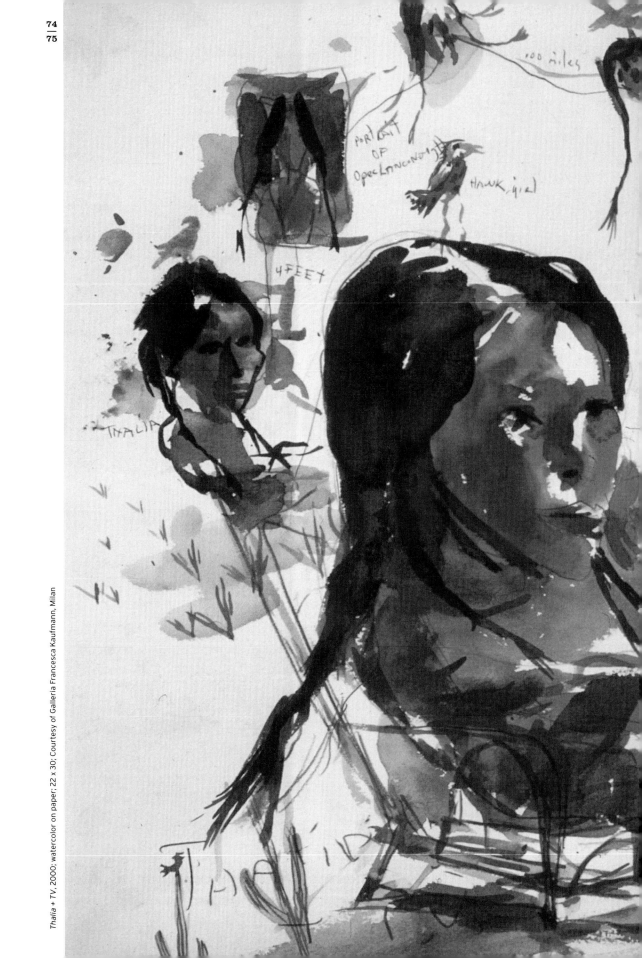

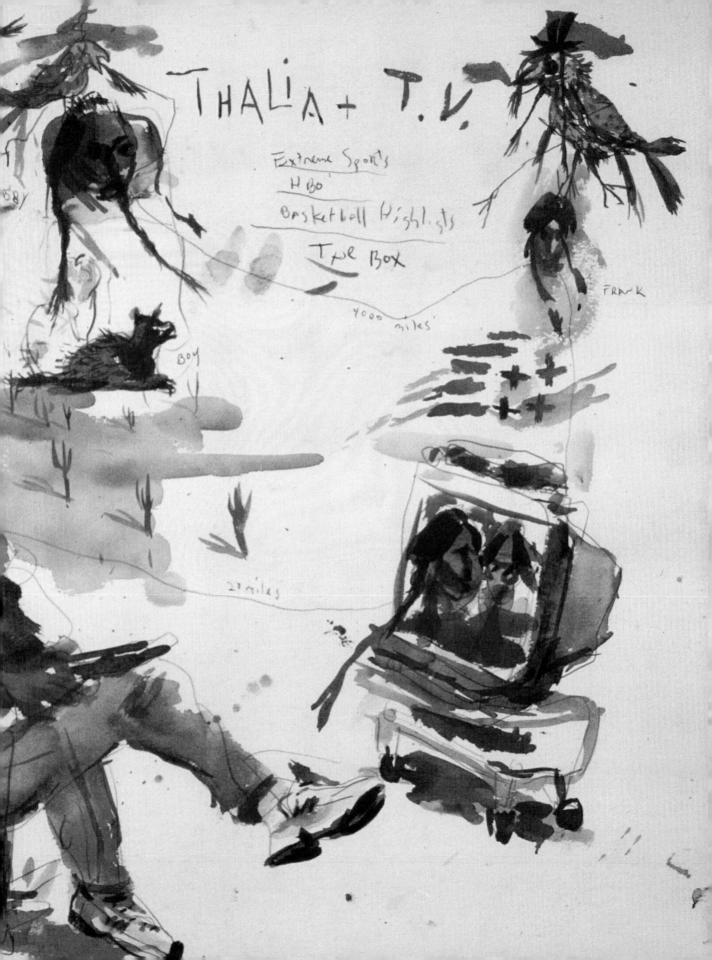

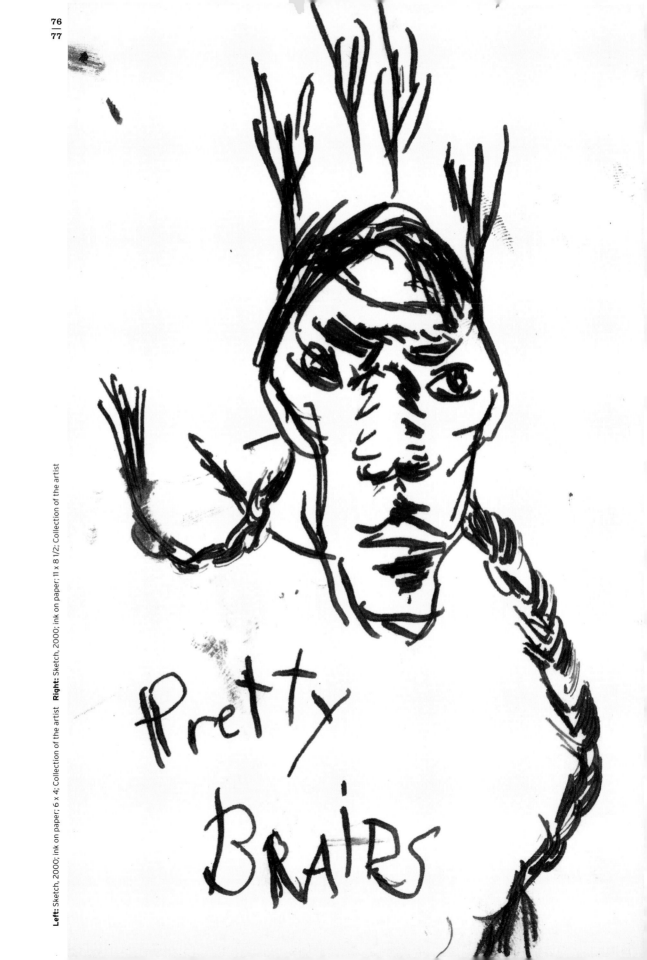

Pretty
Braids

Left: Sketch, 2000; ink on paper; 6 x 4; Collection of the artist **Right:** Sketch, 2000; ink on paper; 11 x 8 1/2; Collection of the artist

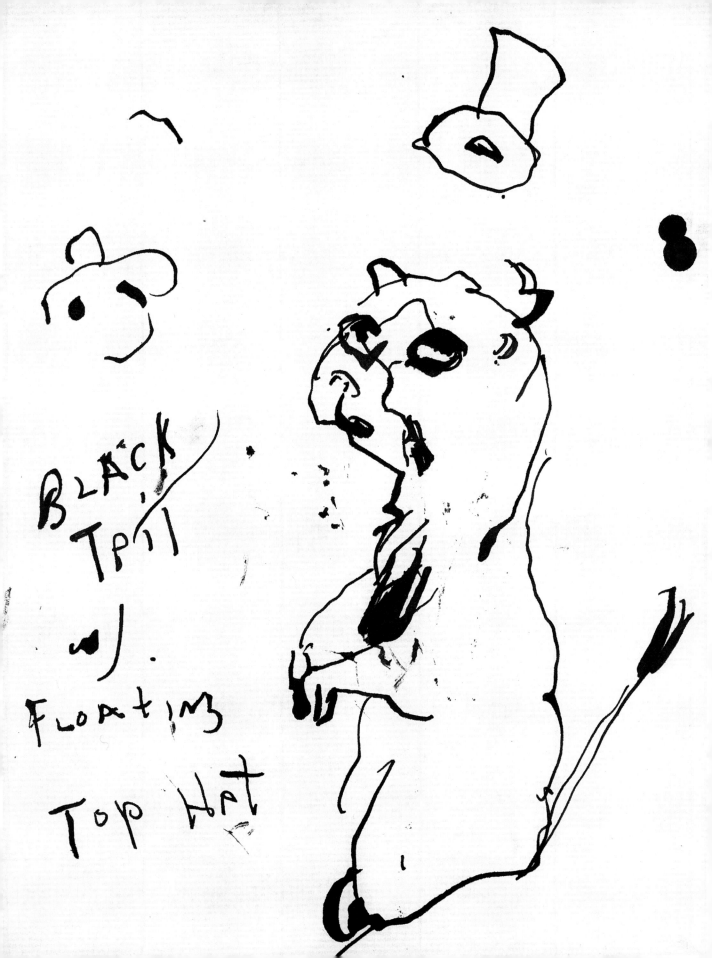

BLACK
TP11
w/.
FLOATING
TOP HAT

Sketch, 2000; ink on paper; 9 7/8 x 14; Collection of the artist

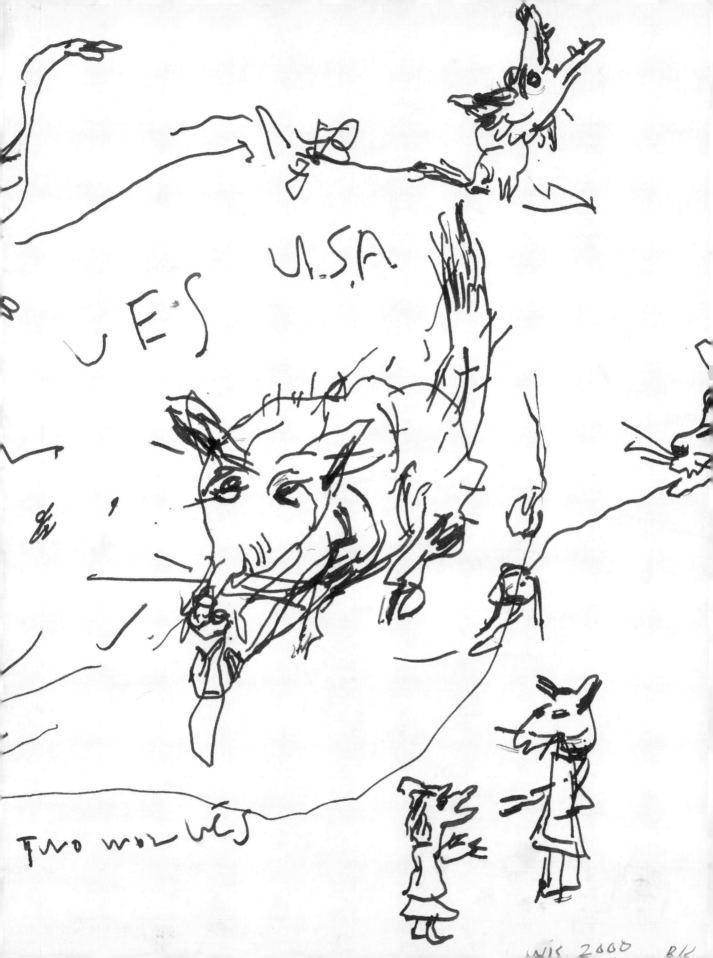

UES U.SA

TWO WOLVES

WIS 2000 RK

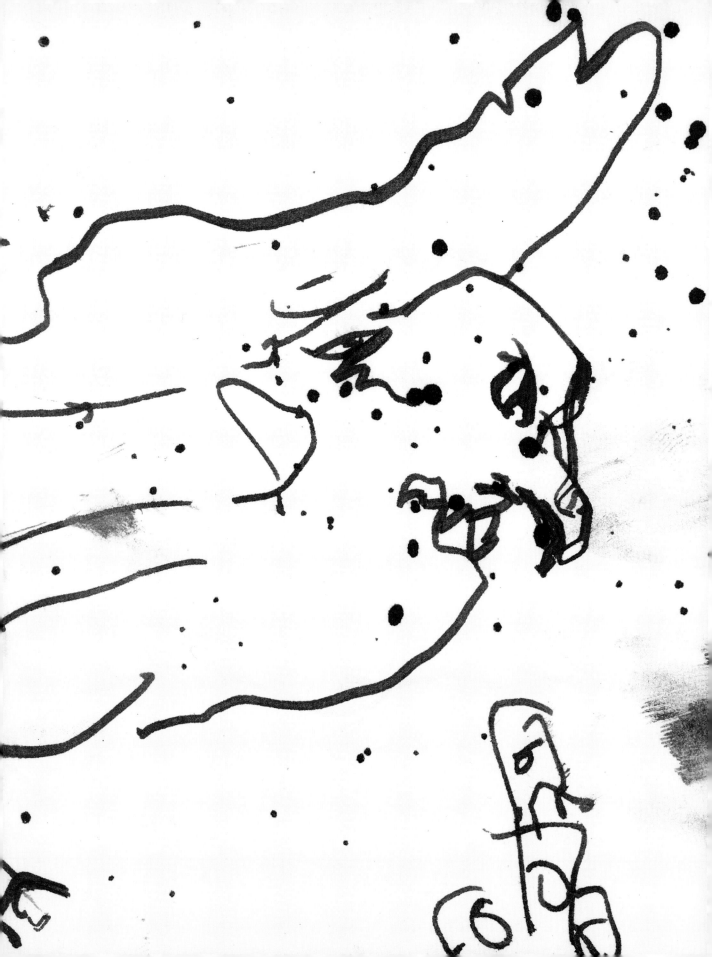

INDIAN

CARVING

A

BEAVER

STICK

Black Hills
S. DAKOTA
AUG 3 2000

Sketch, 2000; pencil on paper; 8 1/2 x 11; Collection of the artist

Sketch, 2000; pencil on paper; 8 1/2 x 11; Collection of the artist

Sketch, 2000; pencil on paper; 8 1/2 x 11; Collection of the artist

Brad Kahlhamer

Born in Tucson, Arizona, 1956
Lives in New York, New York

Education
B.F.A. University of Wisconsin–Oshkosh

Awards
Marie Walsh Sharpe Foundation Studio Grant, 1996

Solo Exhibitions
1994 Project Room, Thread Waxing Space, New York, NY
1996 Bronwyn Keenan Gallery, New York, NY
1998 *KTNN*, Bronwyn Keenan Gallery, New York, NY
1999 *Friendly Frontier*, Deitch Projects, New York, NY
2000 Galleria Francesca Kaufmann, Milan, Italy
 Almost American, Modern Art Inc., London, England
 Brad Kahlhamer: Almost American, Madison Art Center,
 Madison, WI; and Aspen Art Museum, Aspen, CO

Selected Group Exhibitions
1990 Arton A Galleri, Stockholm, Sweden
1992 *Three Sculptors: Leonardo Drew, Lisa Hoke, Brad
 Kahlhamer*, Thread Waxing Space, New York, NY
1993 *W139-NY*, W139, Amsterdam, The Netherlands
 Markets of Resistance, White Columns, New York, NY
 Simply Made in America, Aldrich Museum of
 Contemporary Art, Ridgefield, CT; traveled to
 The Contemporary Arts Center, Cincinnati, OH; Butler
 Institute of American Art, Youngstown, OH; Palm
 Beach Community College Museum of Art, Lake Worth,
 FL; Delaware Art Museum, Wilmington, Delaware
1994 *It's How You Play the Game*, Exit Art, New York, NY
 The Garden of Sculptural Delights, Exit Art, New York,
 NY
1995 *Fifth Annual Cartoon Show*, Max Fish, New York, NY
 Brad Kahlhamer Michael Ashkin, Bronwyn Keenan
 Gallery, New York, NY
 Extremely Refrigerated, Meatlocker, 61 Gansevoort
 Street, New York, NY
 Way Cool Print Portfolio, Exit Art, New York, NY
 Obsession, Chassie Post Gallery, New York, NY
 Chess & Checkers, The Apartment Store, Exit Art,
 New York, NY
 Pop Up, Socrates Sculpture Park, Long Island City, NY
 Lookin' Good, Feelin' Good, 450 Broadway Gallery,
 New York, NY
 Works for a Fun House, E.S. Vandam, New York, NY
1996 *Red River Crossings: Ten Native American Artists
 Respond to Peter Rindisbacher (1806-1834)*, Swiss
 Institute, New York, NY
 Explosion in a Tool Factory, Hovel, New York, NY
 Christie's 1996 Contemporary Art Survey, organized by
 Bronwyn Keenan and Christie's Fine Art Auctioneers,
 New York, NY
 Sweat, Exit Art, New York, NY
 The Art Exchange Show, Bronwyn Keenan Gallery,
 New York, NY
 Scratch, benefit for Thread Waxing Space, New York, NY
 Incestuous, Thread Waxing Space, New York, NY

 Square Bubbles, Mandeville Gallery, Union College,
 Schenectady, NY
 Wish You Were Here, Bronwyn Keenan Gallery,
 New York, NY
 Romper Room, Thread Waxing Space, New York, NY
1997 *Structures*, John Berggruen Gallery, San Francisco, CA
 Landscape USA, Bronwyn Keenan Gallery, New York, NY
 Stepping Up, Andrew Mummery Gallery,
 London, England
 Black & White, Neuberger Museum of Art, Purchase, NY
 *New Museum of Contemporary Art's 20th Annual Gala
 Benefit and Art Auction*, New York, NY
 Road Show '97, Bronwyn Keenan Gallery, New York, NY
 Momenta Art 1997 Benefit, Momenta Art, Brooklyn, NY
 Supastore de Luxe (No. 1), Up & Co, New York, New York
 Esso Gallery, Turin, Italy
1998 *Pets*, Bronwyn Keenan Gallery, New York, NY
 Wall Paper, Nicholas Davies Gallery, New York, NY
 Solo Painting: Voices in Contemporary Abstraction,
 North Dakota Museum of Art, Grand Forks, ND
1999 *Infra-Slim Spaces: The Physical and Spiritual in the Art
 of Today*, organized by 'nvisible Museum' London at the
 Birmingham Museum of Art, Birmingham, AL
 Self Portrait, Mercer Union, Toronto, Ontario, Canada
 *New Museum of Contemporary Art's 22nd Annual Gala
 Benefit and Art Auction*, New York, NY
 Patrick Callery, New York, NY
2000 *Printed*, Karen McCready Fine Art, New York, NY
 Greater New York: New Art in New York Now, P.S.1
 Contemporary Art Center, Long Island City, NY
 End Papers, Neuberger Museum of Art, Purchase, NY
 *The End: An Independent Vision of Contemporary
 Culture, 1982-2000*, Exit Art, New York, NY
 Lost, Ikon Gallery, Birmingham, England
 Ghosts: Loans from the 'nvisible Museum, Delta Axis,
 Memphis TN

Music
KTNN, Full Pelt/BKG Production compact disc, 1998
Scott Hill and Brad Kahlhamer are El Niño.

Books and Catalogues
Archuleta, Margaret and Peter Fleissig. *Brad Kahlhamer:
 Friendly Frontier*. New York: Deitch Projects, 1999.
Diehl, Matt, Matt Freedman, Martha McPhee, and
 Darcey Steinke. *KTNN*. New York: Bronwyn Keenan
 Gallery, 1998.
Iossel, Mikhail. *Square Bubbles*. Schenectady, New York: Union
 College, 1996.
Rosenberg, Barry. *Simply Made in America*. Ridgefield,
 Connecticut: Aldrich Museum of Contemporary Art,
 1992.
Scholette, Gregory, Henry E. Bovay, and Margaret Archuleta.
 *Red River Crossings: Contemporary Native American
 Artists Respond to Peter Rindisbacher (1806-1834)*.
 New York: Swiss Institute, 1996.
Sculpture: Brad Kahlhamer, Lisa Hoke, Leonardo Drew. New
 York: Thread Waxing Space, 1992.

Articles and Reviews

Camhi, Leslie. "Accounts Paid," *The Village Voice*, December 17, 1996, p. 86.

Canning, S.M. "Markets of Resistance," *New Art Examiner*, February 1994, p. 35.

Cohen, Michael. "Brad Kahlhamer," *Flash Art*, January/February 2000, p. 115.

Cotter, Holland. "Art in Review: Red River Crossings," *The New York Times*, November 29, 1996, Late edition, Section C, p. 30.

Cotter, Holland. "Art in Review: Brad Kahlhamer," *The New York Times*, October 29, 1999, Late edition, Section E, p. 39.

Dailey, Meghan. "Brad Kahlhamer," *Artforum*, January 2000, p. 116.

Ebony, David. "Brad Kahlhamer at Bronwyn Keenan," *Art in America*, July 1997, p. 94.

Ebony, David. "Brad Kahlhamer at Bronwyn Keenan," *Artnet*, May 19, 1998, <http://www.artnet.com/Magazine/reviews/ebony/ebony(3)5-19-98.asp>.

Faust, Gretchen. "Reviews: Leonardo Drew/Lisa Hoke/Brad Kahlhamer," *Arts Magazine*, April 1992, p. 94-95.

Freedman, Matt. "Brad Kahlhamer," *Review: Reviews & Previews of Current Exhibitions in New York*, November 1, 1996, n.p.

Halle, Howard. "Graceland," *Time Out New York*, December 11, 1997, p. 45.

Heartney, Eleanor. "Brad Kahlhamer, Lisa Hoke and Leonardo Drew at the Thread Waxing Space," *Art in America*, May 1992, p. 137.

Heiss, Alanna. "Brad Kahlhamer," *Connaissance des Arts*, September 2000, p. 126-27.

Hicks, Robert. "Art: Group Seeks to Wed Sculpture and Theater," *The Villager*, March 23, 1994, p. 12.

Hoptman, Laura. "Brad Kahlhamer," *Interview*, October 1999, p. 326-27.

Jaeger, William. "'Square Bubbles' Perfect for Nott Exhibit Shows Intelligent Use of Display Space," *The Times Union*, April 14, 1996, p. l2.

Johnson, Ken. "Art Guide: Brad Kahlhamer," *The New York Times*, May 15, 1998, Late edition, Section E, p. 36.

Judge, John. "Brad Kahlhamer: Bronwyn Keenan," *zingmagazine*, Fall 1998, p.255-56.

Kino, Carol. "The Emergent Factor," *Art in America*, July 2000, p. 45.

Kornbluth, Elena. "Agenda," *Harper's Bazaar*, October 2000, p. 66.

Larson, Kay. "The Garden of Sculptural Delights," *New York Magazine*, March 28, 1994.

Levin, Kim. "Voice Choices: Leonardo Drew/Lisa Hoke/Brad Kahlhamer," *The Village Voice*, March 3, 1992, p. 69.

Levin, Kim. "Voice Choices: The Garden of Sculptural Delights," *The Village Voice*, April 5, 1994, p. 73.

Levin, Kim. "Voice Choices: Red River Crossings: Contemporary Native American Artists Respond to Peter Rindisbacher (1806-1834)," *The Village Voice*, December 10, 1996, Pullout section, p. 8.

Levin, Kim. "Voice Choices: Brad Kahlhamer," *The Village Voice*, November 9, 1999, p. 87.

Mahoney, Robert. "Brad Kahlhamer," *Time Out New York*, November 14, 1996.

Mahoney, Robert. "Native Speakers," *Artnet*, November 23, 1999, <http://www.artnet.com/Magazine/features/mahoney/mahoney11-23-99.asp>.

Maxwell, Douglas and Gabrielle Gopinath. " Two Critical Comments: Greater New York at P.S.1," *Reviewny.com*, May 1, 2000, <http://www.reviewny.com/current/99_00/may_1/artfeatures1.html>.

Morsiani, Paola. "Leonardo Drew, Lisa Hoke e Brad Kahlhamer," *Juliet Art Magazine*, April 1992, p. 65.

Pohl, Uscha. "Brad Kahlhamer: Bronwyn Keenan Gallery," *zingmagazine*, Summer 1997, p. 282.

Schmerler, Sarah. "Road Show '97," *Time Out New York*, March 13, 1997.

Schwendener, Martha. "Brad Kahlhammer, 'Friendly Frontier,'" *Time Out New York*, November 4, 1999, p. 68.

Servetar, Stuart. "Servetar Selects: Brad Kahlhamer at Bronwyn Keenan," *Artnet*, November 13, 1996, <http://www.artnet.com/Magazine/reviews/servetar/servetar11-13-96.asp>.

Sirmans, Franklin. "The End: An Independent Vision of Contemporary Culture, 1982-2000," *Time Out New York*, March 30, 2000, p. 65.

Staff. "Group Show: Leonardo Drew/Lisa Hoke/Brad Kahlhamer," *The New Yorker*, February 24, 1992, p. 13.

Staff. "Brad Kahlhamer," *The New Yorker*, November 1, 1999, p. 36.

Staff. "Greater New York," *The New Yorker*, March 13, 2000, p. 14.

Staff. "Alternative Space Previews: Center on Contemporary Art, Seattle," *Art in America Annual Guide 2000-2001*, August 2000, p. 30.

Steinberg, Michael. "A New York Mosaic," *Modern Painters*, Spring 1998, p. 114-15.

Stone, Rosetta. "Gallery Yenta," *Artnet*, October 21, 1999, <http://www.artnet.com/Magazine/reviews/stone/stone10-21-99.asp>.

Switzer, Sara. "Quick Takes," *Harper's Bazaar*, October, 1999, p, 168..

Tobler, Lotti. "Native Americans and the Swiss," *Swiss American Review*, October 30, 1996, p. 5.

Vincent, Steven. "The Temporary Contemporary of Linda Farris," *Art and Auction*, April, 2000, p. 38.

Wallach, Amei. "An Exuberant Celebration of Life," *Newsday*, April 1, 1994, p. B17.

Yablonsky, Linda. "Brad Kahlhamer, 'KTTN,'" *Time Out New York*, May 14, 1998, p. 53.